Selected Prints and Drawings 1962-1977

David Hockney

Travels with Pen, Pencil and Ink

Introduction by Edmund Pillsbury

Petersburg Press

Participating Museums

Yale Center for British Art, New Haven, Connecticut
The Minneapolis Institute of Arts, Minneapolis, Minnesota
Cranbrook Academy of Art, Bloomfield Hills, Michigan
William Rockhill Nelson Gallery and Atkins Museum of Fine Arts, Kansas City, Missouri
Hirshhorn Museum and Sculpture Garden, Smithsonian Institution, Washington, D.C.
Art Gallery of Ontario, Toronto, Canada
The Toledo Museum of Art, Toledo, Ohio
The Fine Arts Museum of San Francisco, San Francisco, California
The Denver Art Museum, Denver, Colorado
Grey Art Gallery and Study Center, New York University Faculty of Arts and Science, New York, New York

Library of Congress Catalogue Card Number 77-93603
ISBN Number 0 902825 07 0

Designed by Kinneir Calvert Tuhill Ltd, London
Printed in Great Britain by CTD Printers Ltd, London
Published by Petersburg Press SA

Contents

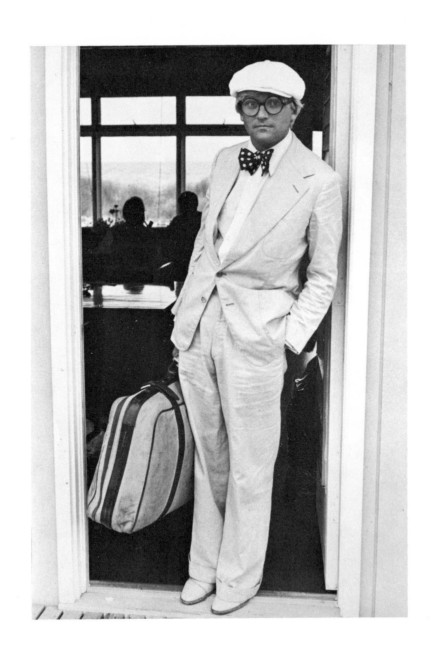

Acknowledgements

This catalogue of prints and drawings has been prepared on the occasion of David Hockney's first major exhibition to tour North America. The works have been grouped into sections representing a selection of those themes which have pre-occupied the artist over the last fifteen years. In the interest of presenting as comprehensive a view as possible, there are numerous works illustrated but not exhibited; hence the catalogue should be used as a companion guide rather than as a precise checklist of the exhibition.

We are indebted to Mr. Edmund Pillsbury, Director of the Yale Center for British Art, for preparing his lucid and informative introduction despite the numerous other demands on his time. We are similarly grateful to Thames and Hudson for permitting the use of quotations from the artist's statements included in their publication.

The works were selected and assembled in London with the critical assistance of both the artist and John Kasmin. They devoted numerous hours to the selection of the prints and drawings, many of which came from their personal collections. We wish to thank particularly those private collectors and museums who have consented to loan drawings for the full period of two years; this is indeed a sacrifice.

The arrangement of the tour has been most ably handled by the International Exhibitions Foundation. Mrs. von Kann and Mrs. Swandby helped us through many difficult moments, while Mrs. Pope gave generously of her time and expertise. We are deeply appreciative of their efforts.

All those involved in London and Washington with the planning and preparation of the tour are grateful to the British Ambassador Mr. Peter Jay, and Mrs. Jay, for undertaking the sponsorship of the exhibition.

Finally, I wish to thank Ruth Kelsey and David Graves, together with the staff at Petersburg Press in London and New York. Neither the exhibition nor the catalogue could have been realised without their patient and cheerful assistance.

P.C.J.

David Hockney: A Modern Romantic
by Edmund Pillsbury

Like English art in general, David Hockney's work is an art of people and places, portraits and landscapes. Although the artist has rejected more traditional forms of portraiture and landscape painting, his art is rooted in the perception of actual persons and locations encountered either first-hand or through the medium of literature, art, or magazine and newspaper illustrations. "My paintings have content, always a subject and a little bit of form," the artist has professed.[1] His subjects, in fact, derive from the poetry he has read, the paintings he has seen, the trips he has taken, and the friends he has made – and combinations of all four. His works are about friendship, politics, literature, and other forms and styles of art. He experiments with different techniques and styles, sometimes on the same canvas, and maintains that this aspect of his work is as important as the figurative or symbolic element. Hockney attempts to achieve in his art a synthesis between the academic training he received as a student at the provincial Bradford College of Art in the 1950's, with its emphasis upon life drawing and the pictorial tradition of Walter Sickert and Degas, and the espousal of abstract expressionism and modernism he made in the early 1960's when he attended the Royal College of Art in London and travelled for the first time to New York, and later to California. If eclecticism, exoticism, complexity, variety and invention are qualities that modernist criticism has placed in disfavor, they represent positive virtues in Hockney's art – elements which he cherishes and has tried to develop over the last two decades. Sometimes eccentric, and often idiosyncratic – but invariably witty and metaphorical – his art succeeds because of, not in spite of, these qualities. To gauge the full range of the intellectual and visual components of Hockney's art, one is obliged to follow its changes and developments – an examination that reveals the presence of not only an underlying unity but also a strong and consistent artistic philosophy.

David Hockney comes from Bradford in Yorkshire, where he was born into a working class family of five children in 1937. At an early age he received encouragement in art and literature from his father, an amateur painter and admirer of Orwell; by eleven he had made up his mind that he wanted to be an artist. At the Bradford Grammar School he remembers making small posters for the Debating Society and illustrations for the school newspaper. In 1953, after finishing his secondary education, he entered the local Bradford School of Art, where he received intensive instruction in anatomy, perspective, figure composition and life drawing – the traditional skills taught in art schools. At Bradford there was little interest in contemporary art; Walter Sickert was the artist held in greatest esteem. In fact, Hockney's first works, which date from his years at the Bradford School of Art, were small-scale portraits and street scenes done from life in a manner recalling that of Sickert. In these works, all of them in oil, the artist restricted himself to likeness and tone; color was of no concern. But by 1957, his last year at the Bradford Art School, the artist had begun to broaden his knowledge of art. In that year he wrote a school paper on the early twentieth-century expressionist painters Kokoschka and Soutine; looked at the works of the British realist painter Stanley Spencer, who had been dismissed by abstract artists and by academic admirers of Degas and Sickert as an eccentric; and became aware of modernist trends in contemporary English art, in particular the works of the abstractionist Alan Davie, whom he admired. Only after he finished his initial training as an artist in Bradford did Hockney have the chance to travel widely to see works by other modern artists in the London museums; he saw his first Picasso at the Tate in the late 1950's. At this time he was painting very little; instead he was reading Proust and fulfilling his National Service requirement as a conscientious objector, working in hospitals in Bradford and Hastings.

In 1959 Hockney enrolled in the Royal College of Art as a post-graduate student. Arriving there, he found the students clearly divided between those doing traditional still-lifes, life painting, and figure compositions as he had done in Bradford and as was practiced in art schools; and those more adventure-

some in spirit, involved in the art of the time, who were painting big abstract expressionist paintings on hard board. When he saw the latter, he decided that *that* was what he had to do and proceeded to paint a series of abstract expressionist-type paintings based on the art of Alan Davie, Roger Hilton and Jackson Pollock. But it did not take the young provincial painter long to discover that there was something "barren" about these works, and he began seeking a means of introducing his concerns for figurative art and for literature, politics and other subjects. Encouraged by his fellow students, the American-born R.B. Kitaj, and the English painter, Richard Hamilton, Hockney began doing pictures with letters: he started writing on paintings. He admits now that at that time he lacked the courage to paint real figures because the idea of figure pictures was "anti-modern"; he would instead write a word to identify the subject of the painting or give a clue to the meaning or title of the work. For example, he would write the word "Gandhi" on a work about the Indian politician. The presence of the word created a feeling about the picture that was more specific. It also forced the viewer to come close to the work and inspect the surface in search of other messages or clues to possible meaning. At the same time, the artist adopted a drawing style based on the primitive treatment of figures in the work of Dubuffet and in children's drawings, by which he was able to overcome the academic kind of draftsmanship he had learned in school and yet remain faithful to the modernist principles of flatness and crude primitivism which he had adopted.

The subjects of the works of this period (1960–63) range from poems, movies and graffiti to particular feelings, ideas or experience. The majority of works are expressionistic in treatment, with stylistic, literary and political references and with an allegorical or polemical message. Three works of the period demonstrate this diversity. The first is a painting of 1960 entitled *Adhesiveness*.[2] The work takes its title from a poem by Walt Whitman who used the word "adhesiveness" to describe the concept of friendship. The painting shows the embrace of two small, upright figures silhouetted against a black border and placed in front of a panel depicting a DeKooningesque abstraction. The numbers drawn on each figure refer to a code used by Whitman to designate letters of the alphabet; by this system "4.8" stands for "DH" or David Hockney, and "23. 23" for "WW" or Walt Whitman. The painting therefore takes on a range of meanings. On one level, it is a purely abstract juxtaposition of colors and shapes on a flat surface; on another it is an allegory of friendship; on a third it is a statement about the shortcomings of abstractionist painting; and on still a fourth level it is a self-portrait of the artist expressing the painter's love of Whitman's poetry. Whitman's poetry inspired another painting of 1960, *The Third Love Painting*. This work is basically an abstract expressionist work which combines lines from Whitman's poems with graffiti and other phrases, all of which serve as pointers to the content of the painting. From a distance one reads the work as a purely abstract composition, with areas of quick, heavy impasto. On closer inspection, though, one sees the letters: first the principal message, then – as if one were inspecting a wall of graffiti in a washroom – the smaller, more "neurotic" ones. While the subject matter of love and boys is a deliberate flaunting of the artist's homosexuality (for which he was criticized at the time), the writing brings the viewer close to the surface of the work and forces him to read the painting in terms of a written message, or code. In this, as well as in the title of the work, there is a criticism of abstract painting, a kind of art which one normally viewed only briefly and from a distance, without an interest in anything beyond the manipulation of the forms and paint, and which normally bore serial titles based on matter-of-fact descriptions of color or purely abstract elements of the composition. Another poet Hockney read during this period is the Greek Alexandrine Cavafy. Cavafy's poems, which Hockney read in translation, had a directness and simplicity that appealed to the painter. In 1961 Hockney visited New York for the first time. On his return he painted a large canvas entitled *A Grand Procession of Dignitaries in the Semi-Egyptian Style*, which is based upon a poem by Cavafy. To illustrate the poem, the artist invented three figures and placed

them in a row under a curtain. This is the first work in which Hockney used a curtain, and he did so because he felt it would help make the whole scene appear theatrical. Apart from achieving this, the curtain's inclusion helps to unify the composition. In his later works, the curtain motif – whether a solid fabric with a pattern or a transparent shower curtain – became an important illusionistic device which the artist exploited as a metaphor for the entire process of painting (*i.e.* decorating the surface of a canvas with a design). It is important that in this work the artist followed the example of his fellow Englishman Francis Bacon, perhaps the most important figure artist in England of his generation, and that of contemporary American Pop artist Larry Rivers (who came to London in 1961), in exposing large portions of unprimed canvas. The title of the work was suggested by the character of Egyptian art, which fascinated the artist because it depended on a set of strict rules from which the individual artist could deviate little. Since Hockney followed only a few of those rules in his work, he called the style of his painting "semi-Egyptian."

As Hockney's work developed in the early sixties, he became more and more conscious of different styles of paintings and the rules associated with each one. Under the influence of Kitaj, he found that he could paint something in one corner in one way and in another in an entirely different way, or style. By doing this he found that style was as important a subject for a painting as a political, literary or other theme. In 1962 he sent four pictures to an exhibition under the general title, *A Demonstration of Versatility*. At the same time he produced a series of paintings which demonstrated various ways of seeing: *Figure in a Flat Style* (1962) is a shaped canvas set on an easel to suggest a figure; *Tea Painting in an Illusionistic Style* (1961) is an illusionistic painted box decorated with a nude figure; and *Domestic Scene, Broadchalke, Wilts.* (1963) shows an interior with two figures seated on a couch and two flower vases painted in a cubist style. The most important work of the series is the large painting executed in 1963 entitled *Play Within a Play*. This painting takes as its subject the series of illusionistic frescoes of Domenichino in the National Gallery in London. These frescoes represent tapestries depicting mythological scenes. Hockney has represented a shallow space in front of a painted curtain as in the Domenichino fresco but has placed in the foreground a chair and full-length portrait of the artist's dealer, Kasmin, who presses himself against a large plate of glass, also illusionistically rendered, as if he were struggling to break through the foreground plane.

In addition to stylistic concerns, Hockney's paintings of the early 1960's also became a vehicle for the expression of political and other views. The artist's mother is a vegetarian and an individual with strong religious convictions; Hockney was brought up neither to smoke nor to eat meat (both of which he now does). The first print the artist did, *Myself and My Heroes* (1961), shows the artist beside two iconoclasts, Gandhi and Whitman, who defined personal freedom in different ways. The two are accompanied by the words "love" and "vegetarian" – a reference to pacifism. The painting *The Cruel Elephant* (1962) can also be read as a political allegory. *Life Painting for Myself* (1962) is a polemic against the Royal College's practice of hiring only unattractive females as life models for drawing. Hockney disliked the practice of drawing from nondescript models because he felt it eliminated feeling. While the College maintained that it was unimportant if the model were beautiful (since one drew to understand the underlying geometries of the figure – *i.e.* the sphere, the cone, and the cylinder, in Cezanne's canon) Hockney maintained that one could not disassociate one's feeling towards the model from one's drawing of it and therefore brought in his own model, Mo McDermott. At that same time, Hockney also painted *The Snake*, in which he shows a snake coiled in a spiral on an unprimed canvas. The work is an attempt to animate a target design used by American painters Jasper Johns and Ken Noland. It thus constitutes a statement on the modernist view of flatness.

The works of the early sixties least burdened with allegory or polemic are the artist's prints. In printmaking, Hockney found a natural and immediate outlet for his fascination with book illustration and literary subjects, a tradition in which

English artists have excelled since the time of Blake. He began printmaking in 1961 because of a need for money and quickly discovered that there was a ready market for his work. On his first trip to New York in 1961 he brought a group of prints with him and succeeded in supporting himself by selling them to museums and collectors. The medium he used was traditional hard ground etching and aquatint, and the subject matter came from Whitman and Cavafy poems, Grimm's Fairy Tales, popular songs, and personal experience. The crowning achievement of his prints in the early sixties is the series of sixteen prints he did of *A Rake's Progress*. Conceived as an updated version of Hogarth's satirical and moralistic paintings in the Soane Museum, set in the city of New York, these prints tell the story of certain of the artist's experiences: his arrival; the sale of his prints to the Museum of Modern Art; his sightseeing tour to Washington and his meeting of the fathers of American democracy; his attending a gospel-singing concert of Mahalia Jackson at Madison Square Garden; the bleaching of his hair (an event that apparently transformed the artist from a shy, retiring person into a happier, more extroverted one); his awareness of physical fitness; his drinking at bars; an affair; closing of bars on Election Day; watching a crime movie; the dissipation of his money; the ill effects of drink; his meeting of a rock music freak; and, finally, "bedlam," where the artist, or rake, has become virtually indistinguishable from those around him (except for a small arrow placed over his head). The progression from innocence and naïveté to knowledge and eventual moral and social decline is reflected in the way the artist, or rake, is portrayed in the series: in the beginning in a free, quickly incised manner and at the end in a self-consciously anonymous and impersonal fashion. As the artist has admitted, what he liked about doing the series was that there was no text to follow; he was telling stories visually with his imagination. To appreciate them, we in turn must interpret them; their meaning is neither literal nor specific.

With the money he received from the sale of *A Rake's Progress*, Hockney for the first time was able to support himself from his work and decided to move to Los Angeles, a place he had read about both in gay magazines and in John Rechy's *City of Night*. The artist had developed an idea about the beauty of the climate and people in California and had even executed an imaginary view of Los Angeles based on how he thought people lived there. (It is a tribute to the artist's imagination that when he finally arrived in California he found the Los Angeles interiors actually looked the way he had depicted them in this picture.) At the same time, Hockney was also growing weary of England and his life there. An episode in 1963 illustrates his general attitude about his own country: The London *Sunday Times,* which was looking for artists to go to various places and make illustrations for the newspaper, invited Hockney to go back to Bradford and execute a series of drawings of the provincial city. Bradford had little appeal for Hockney, however; not only did he find it uninteresting, but he had recently left the city in order to escape the qualities and associations it had for him. He therefore rejected the *Sunday Times'* offer, saying "Not me, I want more exotic things," and instead proposed that he be allowed to go to Honolulu to make a drawing from the top of the Hilton Hotel. The *Sunday Times* eventually decided to send him to Egypt, where he went in September of 1963, shortly before leaving for the United States.

Hockney's arrival in Los Angeles in the early winter of 1964 marks the beginning of a new period in his work. In California Hockney achieved a temporary reconciliation with modernism. Instead of struggling with it or against it, or trying to manipulate it as a style for expressionistic, polemical or other purposes, he came to accept it, limiting his subject matter to pictorial rather than literary or personal themes and adopting many of the modernist techniques (such as acrylic on raw duck) and pictorial conventions (such as white borders to reinforce the picture plane). He painted still-lifes, swimming pools, showers, and interiors, using a palette of bright, unmodulated colors applied with a roller, not a brush, recalling the "cool abstractionist" paintings of Barnett Newman, Kenneth Noland and other Americans. In Los Angeles,

Hockney began to paint real things, things he had seen. This naturalism meant freedom: for the first time he felt he could paint what he saw or what he remembered, or could even, if he liked, make an abstract painting. While the artist began to limit his subjects, his stylistic sources increased. For example, in 1964 he conceived of the idea for *California Art Collector,* a painting Hockney himself terms a work of "pure invention." The painting, which is the first to include a swimming pool, does not represent a specific place but rather the general idea of the house of a California art collector. The work includes a rainbow stripe to suggest the paintings of Morris Louis, a primitive head to suggest a Pre-Columbian object, and some flat geometric shapes to indicate a Turnbull sculpture, all of which are situated under a canopy around a seated female, sources for which can be found in the works of Fra Angelico and Piero della Francesca. Hockney claims that he included the latter because the hotness of the climate and the openness of the houses in Southern California reminded him of Italy. The source for the swimming pool, on the other hand, was an advertisement that appeared in the *Los Angeles Times.*

At this time Hockney also developed a keen interest in the formal problem of representing water and still-lifes. Both subjects provided the opportunity for exploring various kinds of abstractionist patterns in paint. In these works he would begin with a Polaroid snapshot, a drawing, or something he saw in a magazine or newspaper as a general source, then go on to invent the shape and color he desired. Water was of interest because it could be any color or shape; it had no specific visual description. This quality accounts for the large number of works in this period dealing with water, particularly that in richly tiled showers and swimming pools, where the effects of the water were entirely artificial and controlled. The artist's concern for the formal problems of *how* things are seen reached its height in 1965 with the set of lithographs *A Hollywood Collection,* executed at Gemini in Los Angeles. These six prints constitute a small art collection of works of various styles and periods, illusionistically depicted in frames and carefully identified by subject.

At the end of 1965, Hockney returned briefly to London and from there travelled to Beirut in January, 1966, to collect ideas for a series of prints illustrating the poems of Cavafy. This was the first large series of prints the artist had undertaken since *A Rake's Progress* and he maintains that he decided upon it "to counteract all that formalism" in his paintings of the time. He made the trip to absorb the atmosphere of the place and to find specific details that would be of use in creating the setting for the poems. About the same time, Hockney also worked on the designs for the costumes and scenery for Alfred Jarry's deeply satirical, down-to-earth play, *Ubu Roi,* performed at the Royal Court in London. In these designs Hockney followed Jarry's instructions closely, creating very simple sets with rather more elaborate costumes. Not only did both commissions help the artist rekindle his traditional love of drawing, but the actual discipline of doing the illustrations of the Cavafy poems forced Hockney to develop a skill in executing simple line drawings – a technique requiring maximum control and concentration.

When Hockney returned to Los Angeles in 1966, his work displayed a new-found naturalism, liberated at last from "the curse of modernism" and employing naturalistic lighting and illusionistic spatial effects. For the first time, he felt himself completely free to depict the world as he saw it and to impose little of himself on the subjects he painted. Hockney discarded the last vestiges of modernism, which had played so important a part in his works in 1964–66, and replaced it with a naturalism that is at times as cool and impersonal as photo-realism and at times as sentimental and nostalgic as classical studio realism. This development coincided with the artist's first serious interest in portraiture and photography; he bought himself a good camera and started mounting his photographs in albums. During this period he also began experimenting with different techniques of painting in order to vary texture and thereby reinforce the illusion of his works.

The transition to this new phase in his career can be appreciated by comparing two works based on a similar theme: the *California Art Collector* (1964) and *American Collectors*

(Fred and Marcia Weisman) (1968). While the former shows an imaginary person in an entirely fanciful setting, the latter depicts a specific place with a measurable space occupied by real people and by recognizable objects. Instead of his imagination or memory, his sources are photographs he himself made of the garden and drawings he executed of the individuals he wishes to include in the work. A similar comparison may be made between earlier and later swimming pool pictures: for example, *Picture of a Swimming Pool* (1964) and *A Bigger Splash* (1967). The former can be seen as a pure collage of formal elements based on the later work of Dubuffet and the "spaghetti" works of the English painter Bernard Cohen; while the latter illustrates something that took place at a specific time in a particular location. In the latter, the technique of using rollers for the background and then small brushes and little lines for the splash reinforces the illusionism of the scene and creates a *trompe l'oeil* effect similar to that of the "drip" paintings by California Pop Artist Ed Ruscha.

During this period, even technical experiments became the subject of paintings. *Two Stains on a Room on a Canvas* (1967), the artist admits, was an experiment of mixing techniques and using the texture of paint to heighten the illusion. This experimentation in media led finally to Hockney's return to oil painting in 1973.

The portraiture of the period 1966–1968 also developed rapidly. Among the earliest in the group is the 1966 portrait of Los Angeles art dealer Nick Wilder. In general design, this work recalls other swimming pool paintings in which a single figure is shown. The difference here is that the head of the principal figure is based upon life drawings and the setting done from a photograph taken by a person actually standing in the pool. In the beautiful double portrait of *Christopher Isherwood and Don Bachardy* (1968) Hockney went a step further, posing the two subjects of the painting in front of him as he worked and trying to imitate the actual light effects in the room. The furthest he pushed his interest in naturalism seems to have been in the picturesque views of Sainte-Maxime. No doubt the photograph on which *Early Morning,*

Sainte-Maxime,(1968–69)was based interested him because of its association with paintings of sunsets and sunrises by Turner and Claude. Just the same, the painting the artist did from the photograph has a coolness and impersonality akin to that of Malcolm Morley's or Robert Bechtle's contemporary photo-realist works rather than the classical paintings of Claude and Turner, and it is significant that Hockney himself has wondered if this work is not among his least successful.

At any rate, he soon recoiled from the sterile objectivity of the camera lens, and his work since 1968–69 – with the possible exception of the wonderful "conversation piece" of *Mr. and Mrs. Clark and Percy* (1970–71) in the Tate – has sought a release from naturalism by re-introducing abstraction which has allowed him greater freedom to invent and compose. Many of these later works take on surrealist overtones; the mood and sentiment in the pictures recall the lonely isolation of Casper David Friedrich's landscapes and Edward Hopper's deserted street scenes. The surfaces of the works have become more sensuous and varied; the subjects more evocative and suggestive, and less purely descriptive.

The change can be seen in several areas. In portraiture, for example, the painting of *Henry Geldzahler and Christopher Scott* (1969) has a more ordered and calculated compositional structure than that of *Christopher Isherwood and Don Bachardy* (1968). The furniture, the perspective lines on the floor, and the position of the table all lead the eye to the head of the principal figure, which is placed, target-like, in the absolute center of the rectangle. The ordering of the scene gives the head of the central figure immediacy and presence – an effect further emphasized by the penetrating, fixed gaze of the figure himself. Similarly, *Le Parc des sources, Vichy* (1970), which employs a Magritte-like view of the back sides of two seated friends, shows an alley of trees in a park which converge uncomfortably along a thin line in the distance. Beside the two figures is an empty chair reserved for the artist. Hockney has considered titling this work *Play Within A Play*, recalling a theme he used for the 1963 portrait of his dealer, Kasmin. A similarly haunting air exists in *Still Life on a Glass Table*

(1971–72): at first glance this appears to be a straightforward depiction of a table containing a number of ordinary objects, but upon closer inspection one perceives a carefully arranged catalogue of Hockney's personal mementos, poignantly emphasized by the blandness of the wall behind, the tomb-like quality of the glass slab of the table, and the anthropomorphic shadow cast by the objects on the floor beneath the table. In *French Shop, Beach Umbrella,* and *Rubber Ring Floating in a Swimming Pool* (all 1971), the long shadows and sense of isolation bring to mind the work of Edward Hopper, as well as that of Giorgio DeChirico and Max Ernst.

As in the early sixties, the turning point in Hockney's later work seems to have come as a result of a print commission: in this case, the decision in 1969 to illustrate the *Fairy Tales* of the Brothers Grimm. The artist had done some etchings based on Grimm's stories in the early sixties, for example, *Rumpelstiltskin,* but this project was designed to be a much larger and more ambitious undertaking. The stories themselves appealed to the artist for several reasons. They were told in a simple and direct style and language; and they covered a strange range of experience, from the magical to the moral (the emphasis here should be on the word "strange"). Hockney treated the stories he selected not in the usual fashion of showing the most important event in the story but focusing instead on details, telling the story in terms of images evoked by the descriptions in the text rather than by events in the narrative. By the time he finished the group he had made 80 etchings. These are among his most imaginative and inventive creations, drawing not only upon medieval or period sources – Carpaccio (for costumes), Uccello, Leonardo, and Bosch, among others – but also upon modern ones such as Magritte.

In the late sixties, as he became more interested in both portraiture and in the problems of depicting space and exploiting naturalistic light effects, Hockney devoted greater attention to drawing. In 1969 he executed a particularly beautiful group of line drawings portraying writers W.H. Auden and Stephen Spender, as well as various friends. Since 1970, drawing has become an activity of importance in and of itself, independent of the preparation of paintings. Accordingly, the works are becoming increasingly ambitious and complicated. The best known examples are the developed studies of individual figures or objects or of places, executed in colored pencils. These drawings have both the finish and coloristic richness of his paintings, and making these drawings has come to serve as a substitute for painting itself. Moreover, while he once produced them in the space of a few hours, Hockney now takes more time to plan and execute his drawings and on occasion requires several days to bring one to completion.

In printmaking, his work has also continued to develop. He has made a series of large-scale lithographs based on portrait drawings of friends, including one or two very impressive prints of Celia Birtwell, the only woman he has ever known well. These works have the richness and the graphic subtleties of his colored pencil drawings. He also made a series of six lithographs based on his trip to Japan in 1971. Entitled *Weather Series,* these employ various colors and tonal effects to illustrate six different climatic conditions: snow, wind, rain, sun, mist and lightning. More recently, through working with Picasso's former printer in Paris, Aldo Crommelynck, Hockney has developed and expanded his knowledge of intaglio printing. Crommelynck taught him how to do sugar-lift and color etching using soft ground; as a result, he has been able to make the more complex prints of *Contre-jour in the French Style* and *Two Vases in the Louvre* (1974), which exploit the lighting and coloristic qualities of his paintings of the same subjects. With this increased technical confidence, the artist has returned to book illustration. The very whimsical yet beautifully refined set of color prints based on Wallace Stevens' poem, *The Man with the Blue Guitar,* reveals a mastery of the full range of color printing techniques. In this series, Hockney mixes visual and literary puns and references; the title of the series suggests a wide range of imagery: "Etchings by David Hockney who was inspired by Wallace Stevens who was inspired by Pablo Picasso."

Hockney's most recent paintings also explore new technical problems. When he arrived in Paris in 1973, he decided

he would take up oil paints. At first, however, he had trouble with the medium because he was using it as if it were acrylic. He finally overcame this difficulty by consciously adopting a traditional technique of oil painting: pointillism. (He also was attracted to this technique because he was living in France and felt a desire to do a truly "French" picture, which required a "French" style). In the lovely painting *Contre-jour in the French Style* – a view from a window in the Louvre – he uses the pointillist technique to depict the effect of light pouring into the center of the composition, illuminating the brightly-colored window embrasure.

In his more recent work, Hockney has continued to explore technical problems but with a greater awareness of his own literary and personal interests. The *Self Portrait with Blue Guitar* which he recently completed shows the artist seated quietly behind a curtain, drawing a guitar on a piece of paper. Around him are a rug with a design recalling a Turnbull sculpture, a striped rug recalling a Ken Noland painting, a table painted in a pointillist style, a vase of tulips (the artist's favorite flower), a Picasso head, a sheet of glass, a diagram of a house, and other signs. The key to this work is the artist's activity: drawing the guitar. The guitar symbolizes the quality which the artist has grown to consider his most vital and unique tool as a painter: imagination, or inner vision. As one writer observed: "The difference between the highly literary quality of Hockney's early work and the painterly of his later portraits, landscapes, interiors and flower pieces is perhaps that in the early work he was occupied with painting poetry and in his later work he is occupied in making realism poetic."[3]

1 *David Hockney by David Hockney*, edited by Nikos Stangos, Thames & Hudson, London and Harry N. Abrams, New York, 1976, page 61. This fascinating book is a rich source of information about the artist and his work and has provided the basis for this essay.

2 This and the bulk of other Hockney works discussed are illustrated in the artist's autobiography (for which see note 1 above).

3 Quoted from Stephen Spender's introduction to the catalogue of the exhibition of Hockney's work held in the Musée des Arts Décoratifs in Paris in 1974.

Colonial Governor, 1962. *Crayon*, 13 x 10 inches (33 x 25.5 cm)
Figure Composed of Two Red Spheres and a Rectangle, 1963. *Pencil and crayon*, 12.25 x 10 inches (31 x 25 cm)
American Cubist Boy, 1964. *Pencil and crayon*, 11 x 14 inches (28 x 36 cm)
Bob Aboard the 'France', 1965. *Pencil and crayon*, 19 x 24 inches (48.5 x 51 cm)
Coloured Curtain Study, 1963. *Pencil and crayon*, 16 x 12.5 inches (41 x 31 cm)
Cubistic Woman, 1963. *Pencil and crayon*, 12.25, x 9.75 inches (31 x 25 cm)
Shower Study, 1963. *Chalk and pencil*, 19.75 x 12 inches (50 x 30.5 cm)
American Boys Showering, 1963. *Pencil and crayon*, 19.75 x 12.5 inches (50 x 31.5 cm)
Evil Man, 1963. *Crayon*, 20 x 12.5 inches (51 x 32 cm)
The Hypnotist, 1963. *Etching and aquatint*, 19.75 x 19.75 inches (50 x 50 cm)

1 'For an artist the interest of showers is obvious: the whole body is always in view and in movement, usually gracefully, as the bather is caressing his own body. There is also a three-hundred-year tradition of the bather as a subject in painting. Beverly Hills houses seemed full of showers of all shapes and sizes – with clear glass doors, with frosted glass doors, with transparent curtains, with semi-transparent curtains.'

2 'My version has a rather evil-looking hypnotist and an innocent helpless-looking boy (he has no visible arms). This is one of the few early paintings from which I also made an etching. I drew the etching plate with the figures in the same positions as in the painting, but of course when it was printed it was reversed. Seeing both pictures together made me realize that even pictures are read from left to right.'

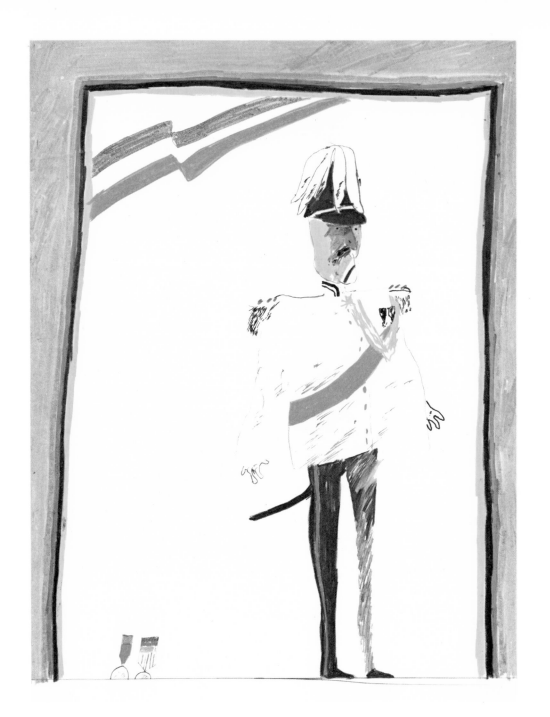

Colonial Governor, 1962

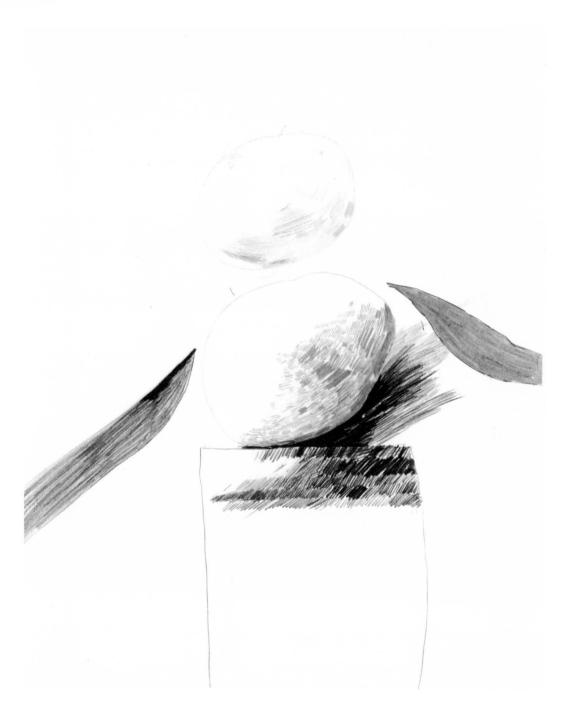

Figure Composed of Two Red Spheres and a Rectangle, 1963

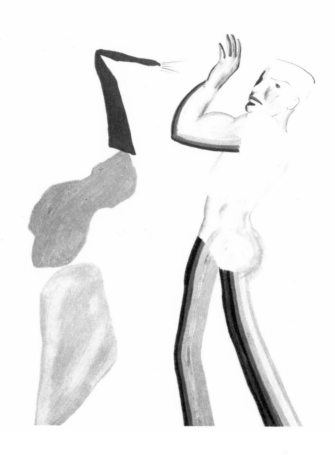

American Cubist Boy, 1964

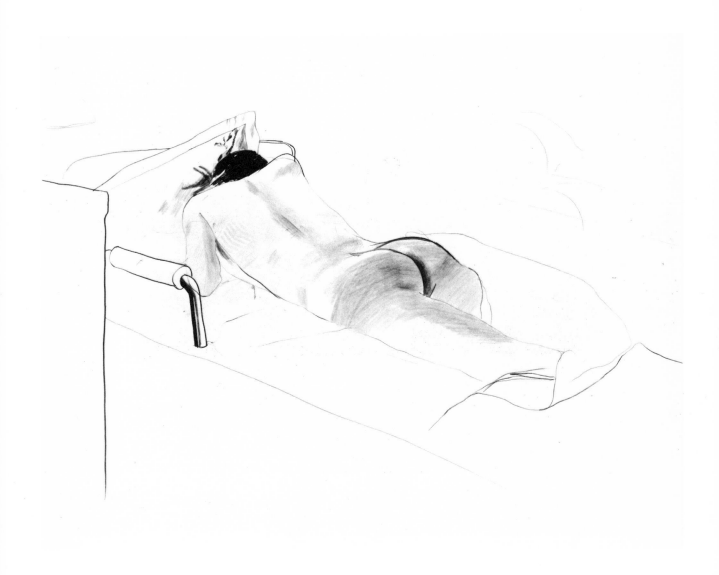

Bob Aboard the 'France', 1965

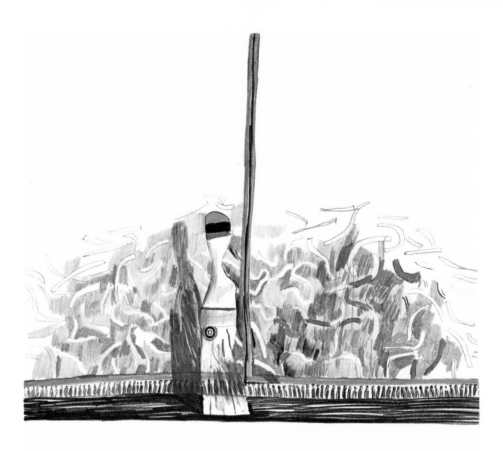

Coloured Curtain Study, 1963

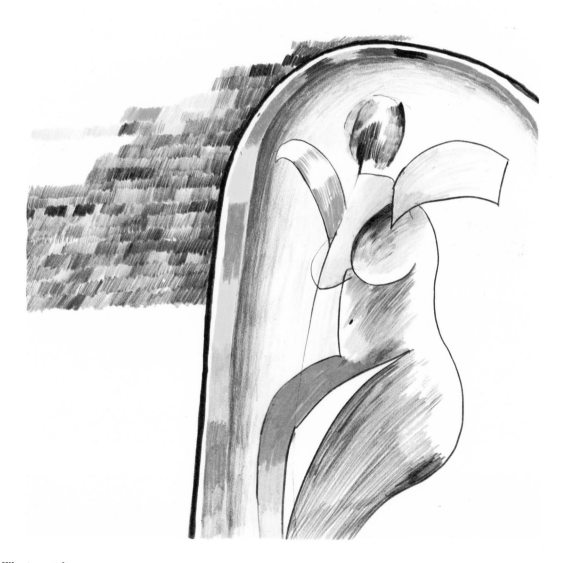

Cubistic Woman, 1963

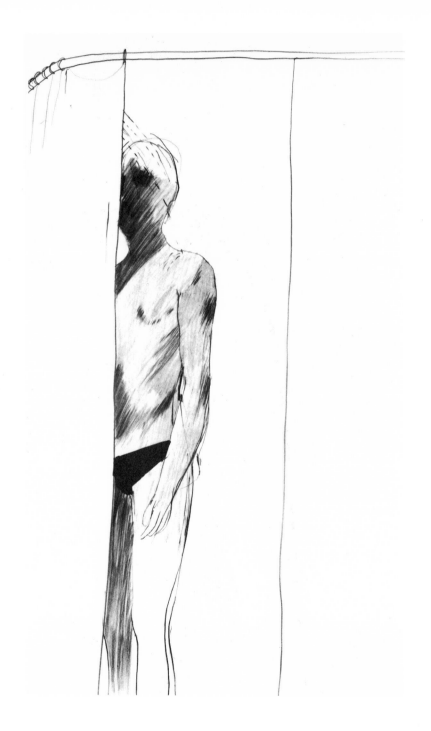

Shower Study, 1963

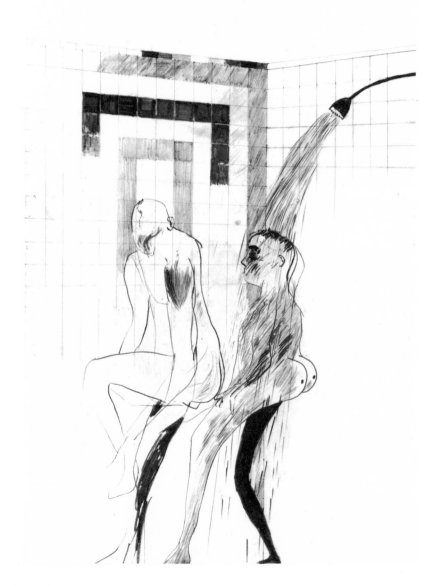

American Boys Showering, 1963

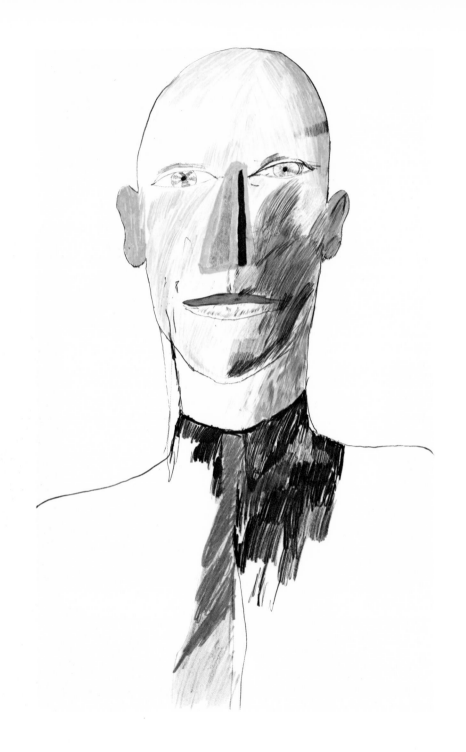

Evil Man, 1963

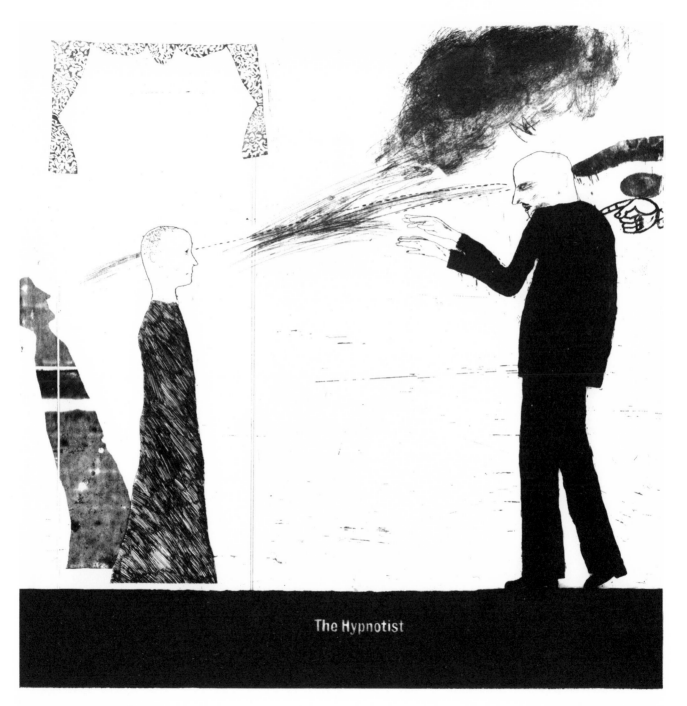

The Hypnotist

The Hypnotist, 1963

Celia in a Black Slip, Reclining, 1973. *Crayon*, 19.75 x 25.5 inches (50 x 65 cm)
Celia, Marrakesh, 1971. *Crayon*, 17 x 14 inches (43 x 35.5 cm)
Celia, Paris, 1969. *Ink*, 17 x 14 inches (43 x 35.5 cm)
Celia, 8365 Melrose Avenue, 1973. *Lithograph*, 47.5 x 31.5 inches (121 x 80 cm)
Celia in a Black Dress with Red Stockings, 1973. *Crayon*, 25.5 x 19.75 inches (65 x 50 cm)
Celia, Carennac, 1971. *Crayon*, 17 x 14 inches (43 x 35.5 cm)
Celia, 1969. *Etching and aquatint*, 27 x 21.25 inches (68.5 x 54 cm)
Celia Half Nude, 1975. *Crayon*, 25.5 x 19.75 inches (65 x 50 cm)
Celia 1972, 1972. *Crayon*, 17 x 14 inches (43 x 35.5 cm)
Celia in a Black Dress with White Flowers, 1972. *Crayon*, 17 x 14 inches (43 x 35.5 cm)

1 'Portraits aren't just made up of drawing, they are made up of other insights as well. Celia is one of the few girls I know really well. I've drawn her so many times and knowing her makes it always slightly different. I don't bother about getting the likeness in her face because I know it so well. She has many faces and I think if you looked through all the drawings I've done of her, you'd see that they don't look alike . . .'

2 'Celia has a beautiful face, a very rare face with lots of things in it which appeal to me. It shows aspects of her, like her intuitive knowledge and her kindness, which I think is the greatest virtue. To me she's such a special person.'

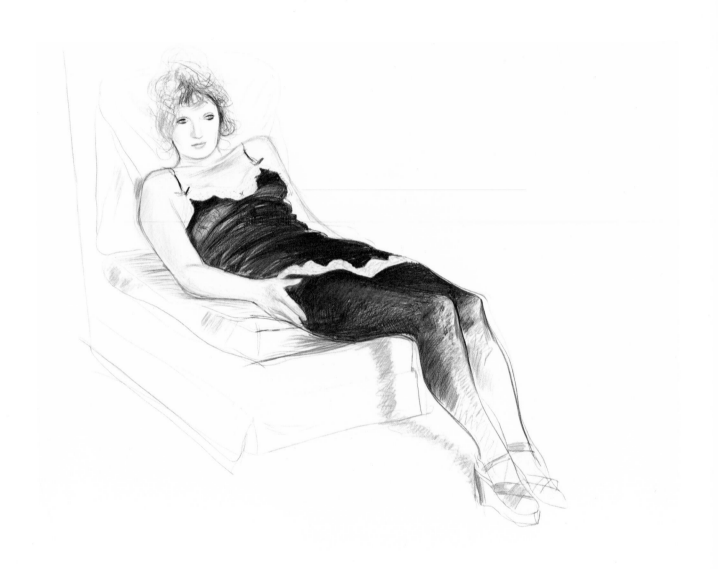

Celia in a Black Slip, Reclining, 1973

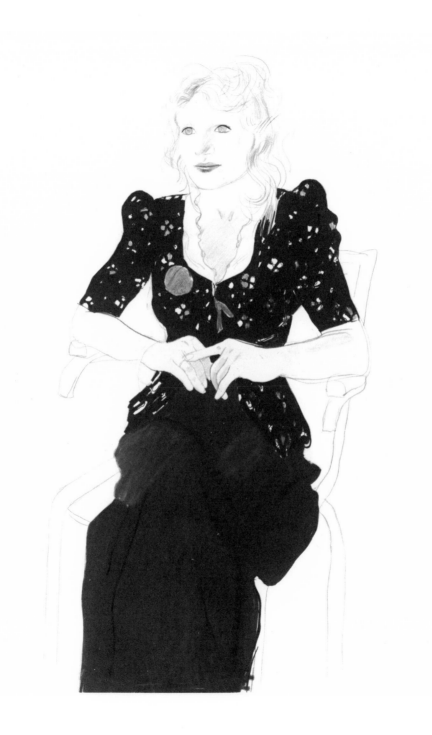

Celia, Marrakesh, 1971

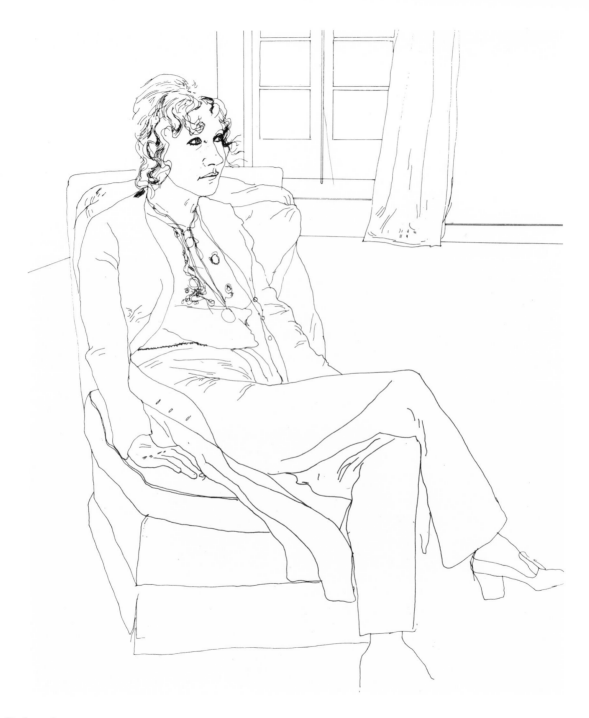

Celia, Paris, 1969

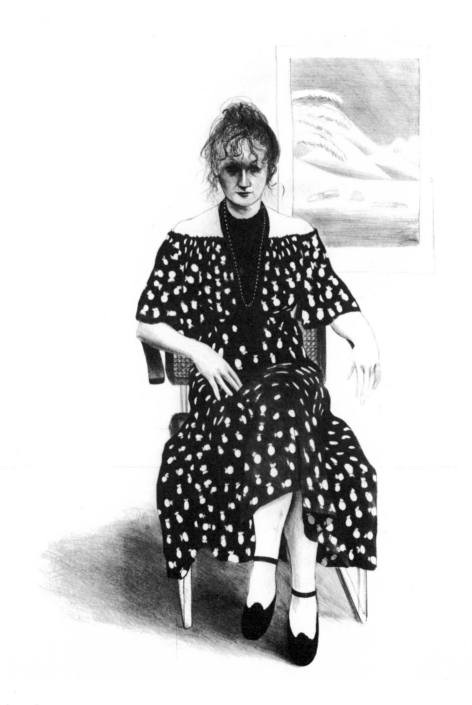

Celia, 8365 Melrose Avenue, 1973

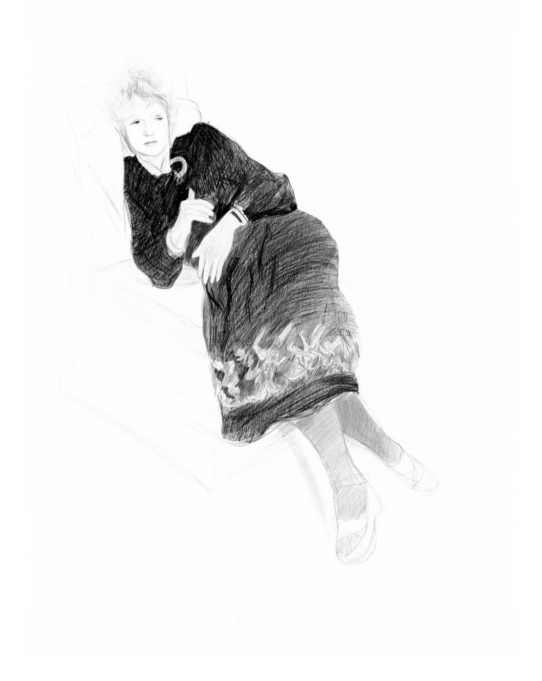

Celia in a Black Dress with Red Stockings, 1973

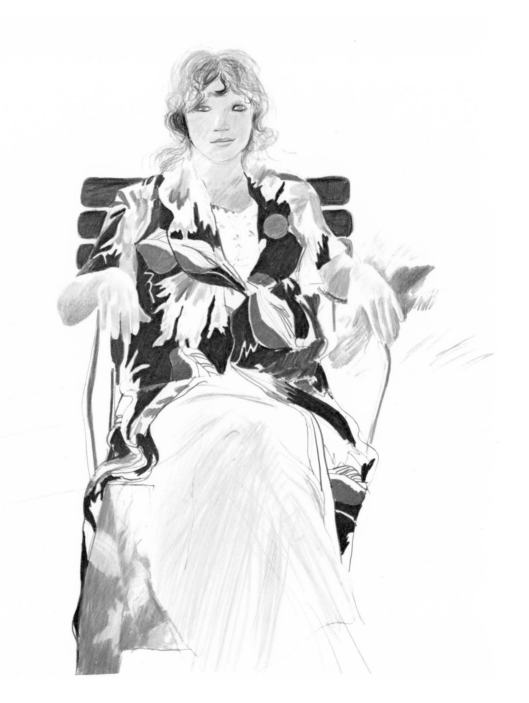

Celia, Carennac, 1971

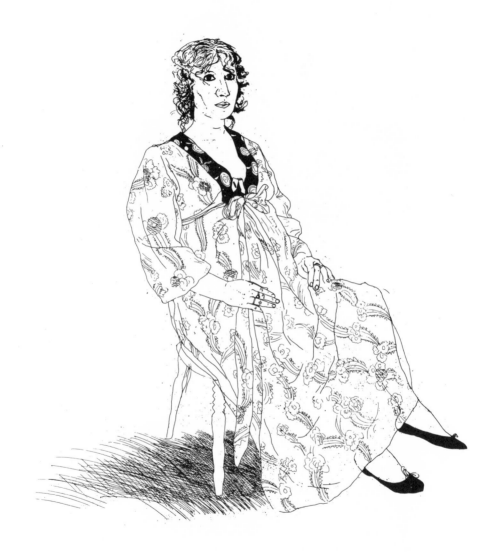

Celia, 1969

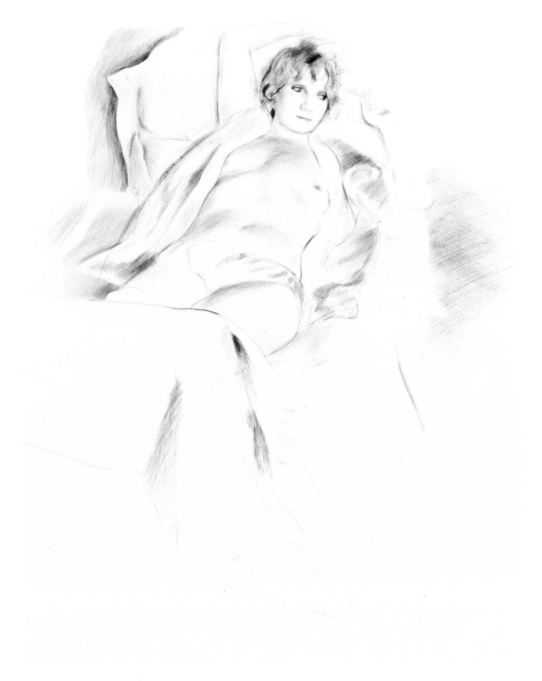

Celia Half Nude, 1975

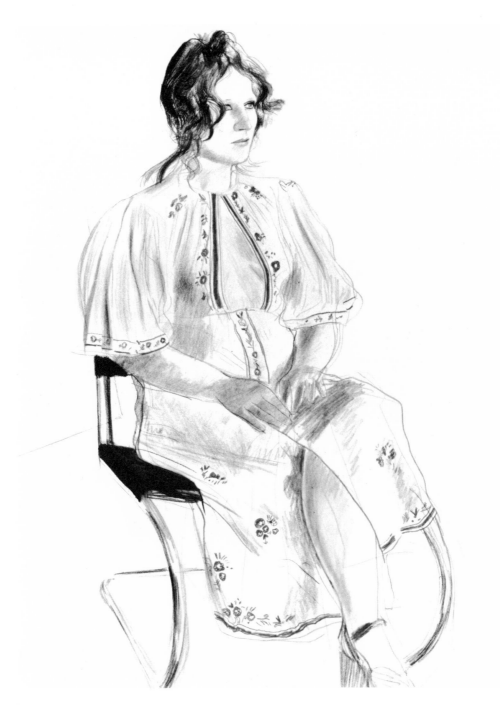

Celia 1972, 1972

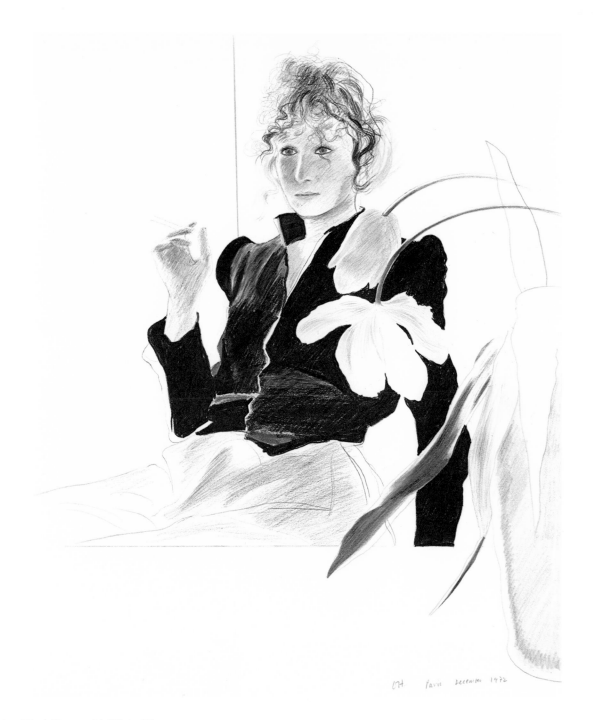

Celia in a Black Dress with White Flowers, 1972

Selections from A Rakes Progress, 1961-63
A Hollywood Collection, 1965
Selections from illustrations for fourteen poems from C. P. Cavafy, 1966

1 'I was doing *A Rake's Progress*, which I'd started in 1961; I didn't finish it till 1963, because it was a long job. I didn't have an assistant then. I started on it when I came back from New York. My original intention was to do eight etchings, to take Hogarth's titles and somehow play with them and set it in New York in modern times. What I liked was telling a story just visually. Hogarth's original story has no words, it's a graphic tale. You have to interpret it all.'

2 'It's a kind of home-made art collection with bits of everything in it, a nude, an abstract, a landscape and so on. I was working with a printer in Hollywood whose workshop was behind a framer's. He had all these marvellous frames in the window. I got interested in this trompe l'oeil thing – a picture of a thing within something else within something else.'

3 'I went to Beirut in January 1966 just to get atmosphere and drawings for the prints. And I found more in Beirut than in Alexandria because when I went to Alexandria all the Europeans had left. I thought Beirut was more like Alexandria would have been when Cavafy was there: cosmopolitan, different groups of people, French and Arabic. I know there's not much Greek population, but I thought it would be better to go there. I went for two weeks and did drawings of buildings, people. I walked through all the seedy bits of Beirut, picking up things. It was very good.'

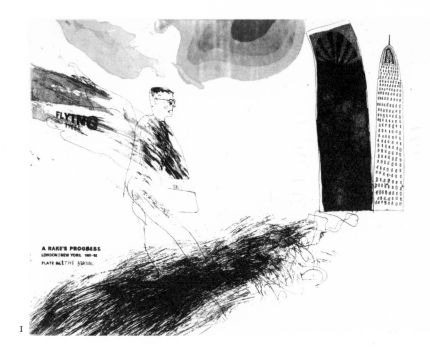

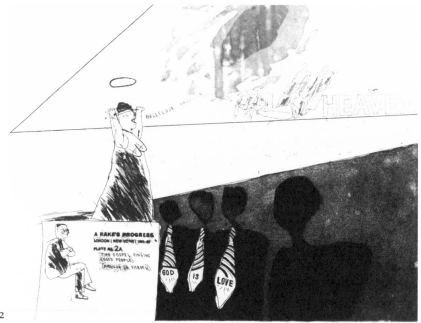

A Rakes Progress, 1961-63

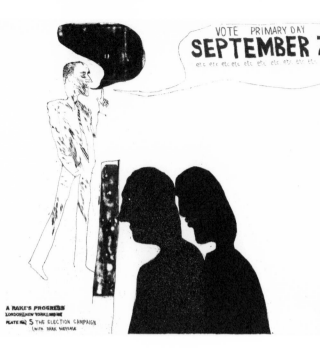

A RAKE'S PROGRESS
LONDON/NEW YORK/1961-63
PLATE No. 5 THE ELECTION CAMPAIGN
(WITH DARK MESSAGE)

3

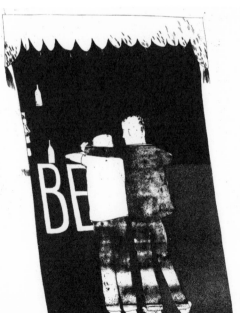

BAR

A RAKE'S PROGRESS
LONDON / NEW YORK / 1961-63
PLATE No. 4 THE DRINKING SCENE

4

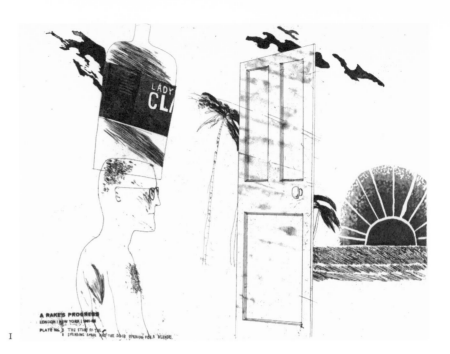

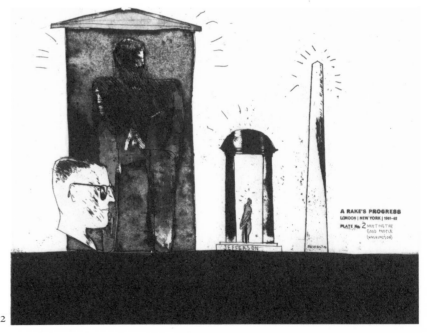

A Rakes Progress, 1961-63

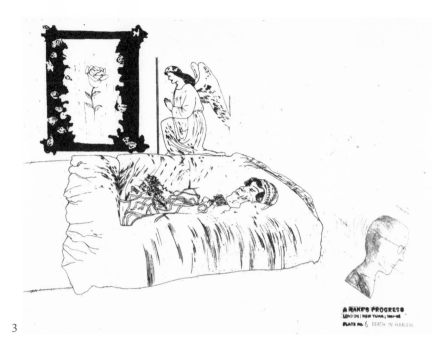

A RAKE'S PROGRESS
LONDON / NEW YORK / 1961-63
PLATE No. 6 DEATH IN HARLEM

3

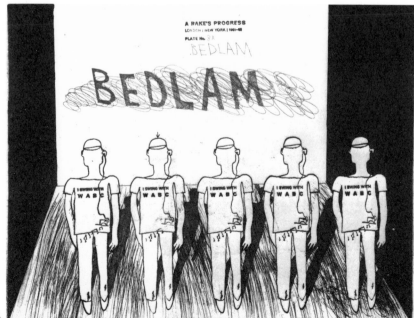

A RAKE'S PROGRESS
LONDON / NEW YORK / 1961-63
PLATE No. 8 A
.BEDLAM

BEDLAM

4

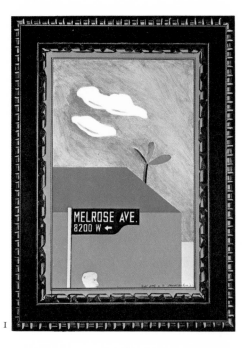

1

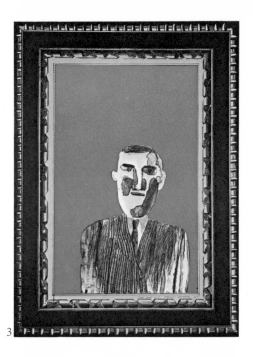

3

2

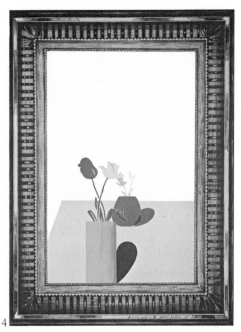

4

5

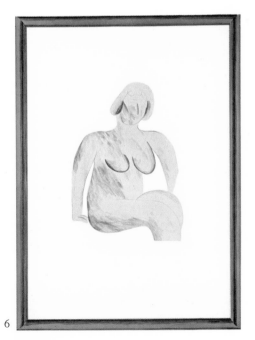

6

A Hollywood Collection, 1965

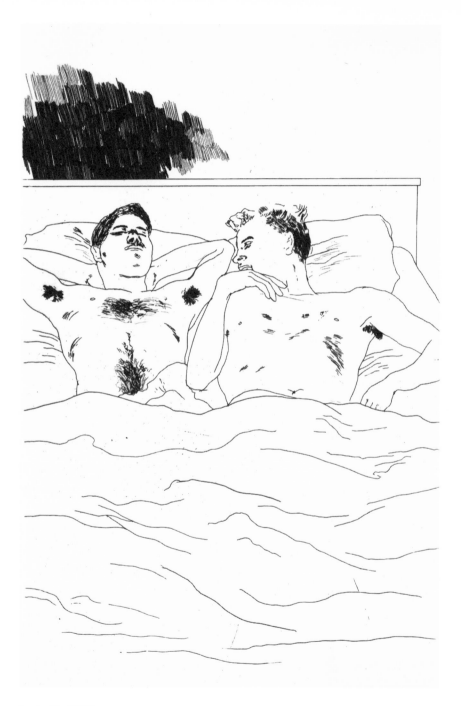

C.P. Cavafy In the Dull Village, 1966

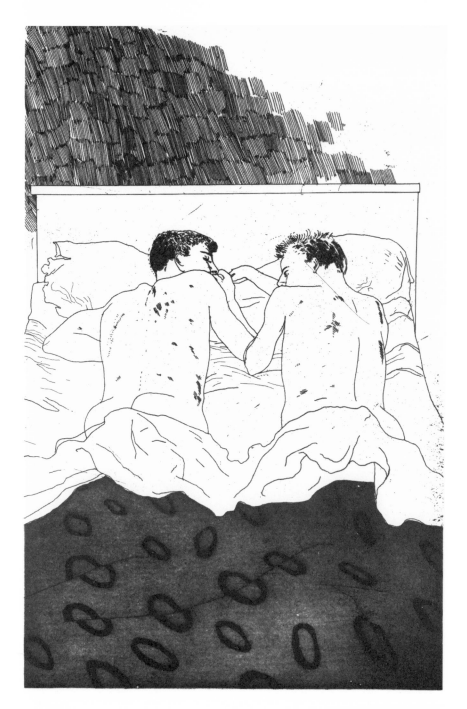

Two Boys Aged 23 and 24, 1966

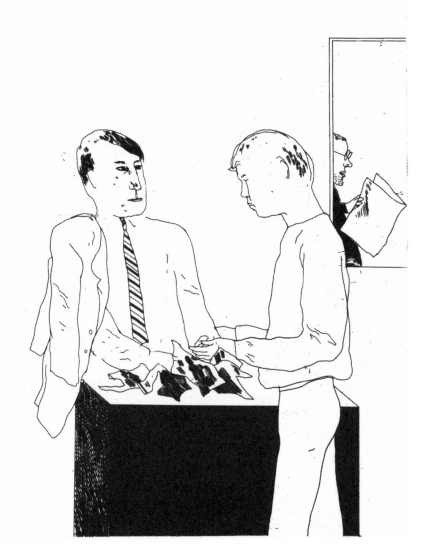

He Enquired After the Quality, 1966

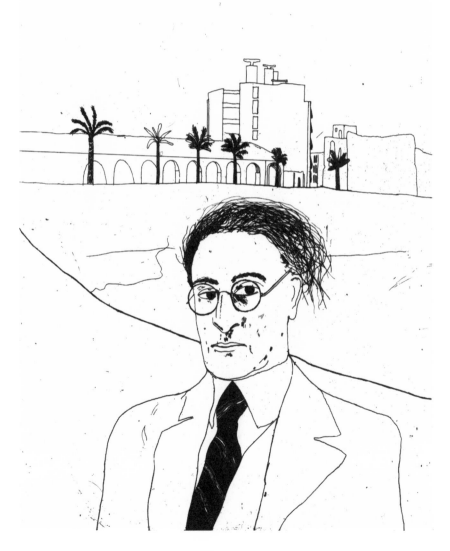

C.P. CAVAFY IN ALEXANDRIA

Portrait of Cavafy I, 1966

Still Life, Taj Hotel, Bombay, 1977. *Crayon*, 17 x 14 inches (43 x 35.5 cm)
Panama Hat, 1972. *Etching and aquatint*, 17 x 14 inches (43 x 35.5 cm)
Chairs, Mamounia Hotel, Marrakesh, 1971. *Crayon*, 14 x 17 inches (35.5 x 43 cm)
Home, 1969. *Etching*, 18 x 13 inches (46 x 33 cm)
Corbusier Chair and Rug, 1969. *Crayon*, 17 x 14 inches (43 x 35.5 cm)
My Suit and Tie, 1971. *Crayon*, 17 x 14 inches (43 x 35.5 cm)
Villa Reale, Marlia (detail), 1973. *Crayon*, 14 x 17 inches (35.5 x 43 cm)
Chair, 1972. *Crayon*, 17 x 14 inches (43 x 35.5 cm)
Royal Hawaiian Hotel, Honolulu, 1971. *Crayon*, 14 x 17 inches (35.5 x 43 cm)
Suginoi Hotel, Beppu, 1971. *Crayon*, 14 x 17 inches (35.5 x 43 cm)

'When you walk into a room you don't notice everything at once and, depending on your taste, there is a descending order in which you observe things. Consequently, I deliberately ignored the walls and I didn't paint the floor or anything I considered wasn't important.'

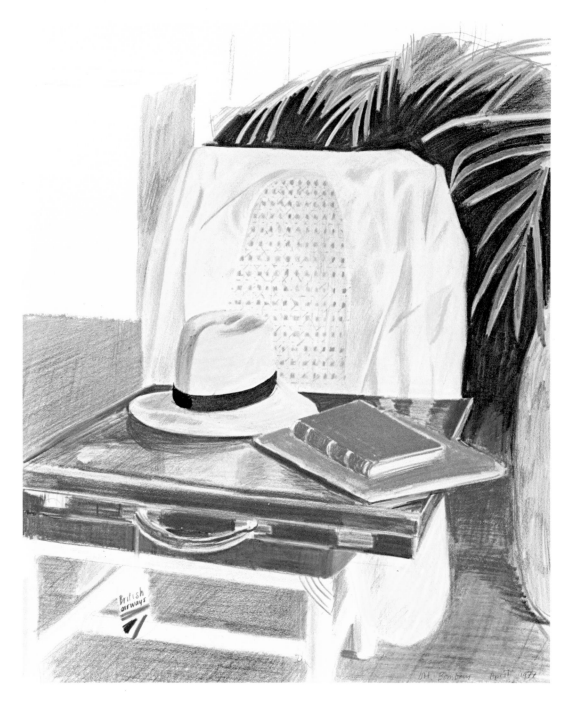

Still Life, Taj Hotel, Bombay, 1977

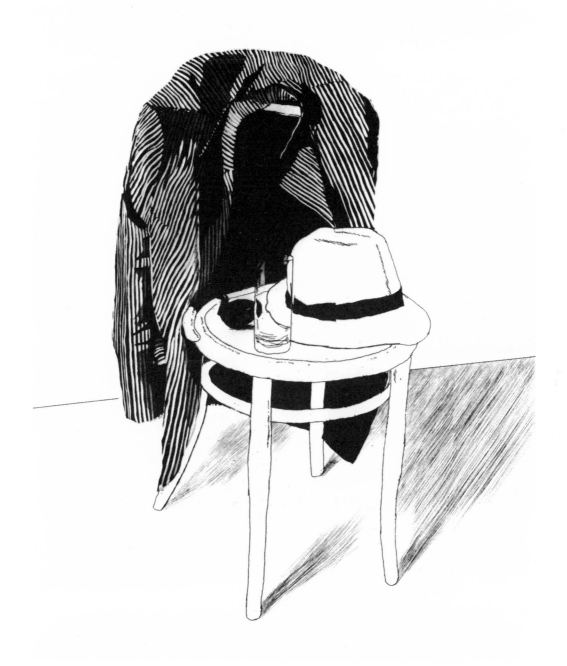

Panama Hat, 1972

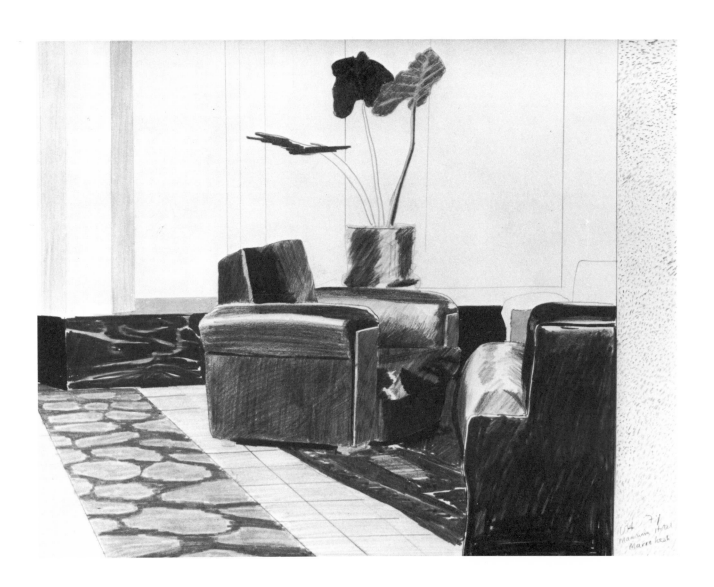

Chairs, Mamounia Hotel, Marrakesh, 1971

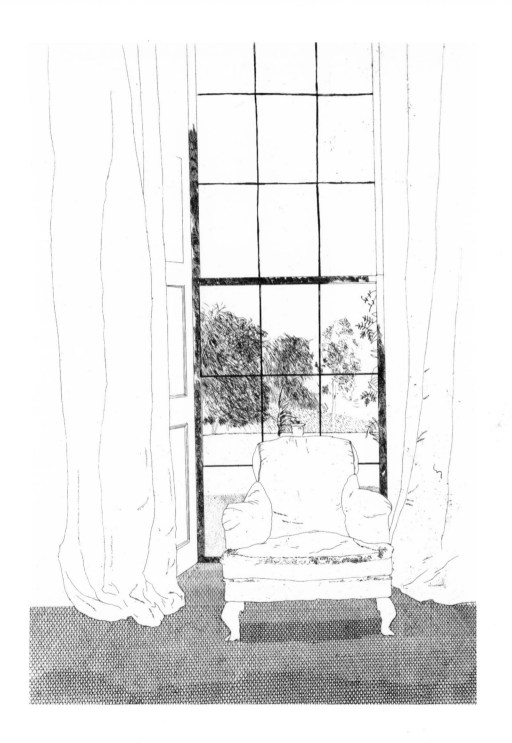

Home, 1969

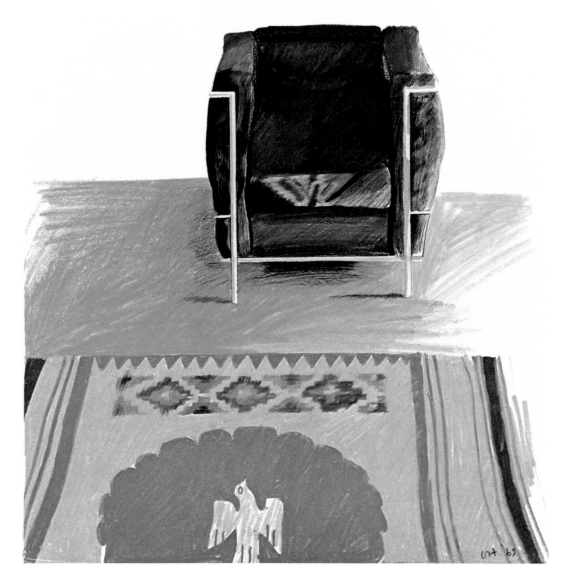

Corbusier Chair and Rug, 1969

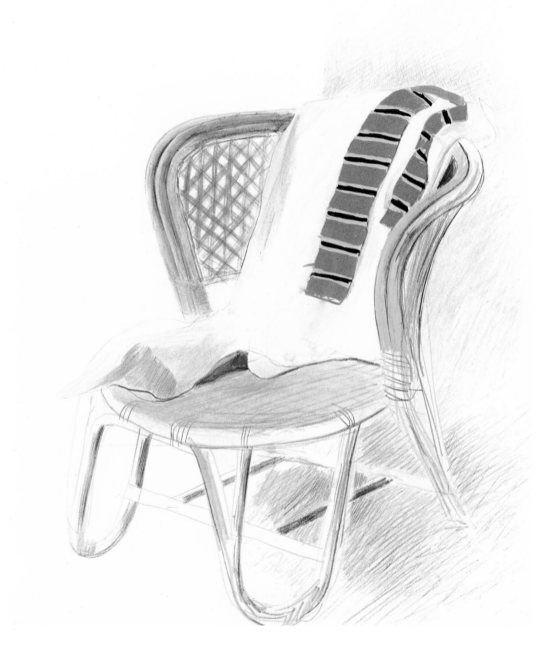

My Suit and Tie, 1971

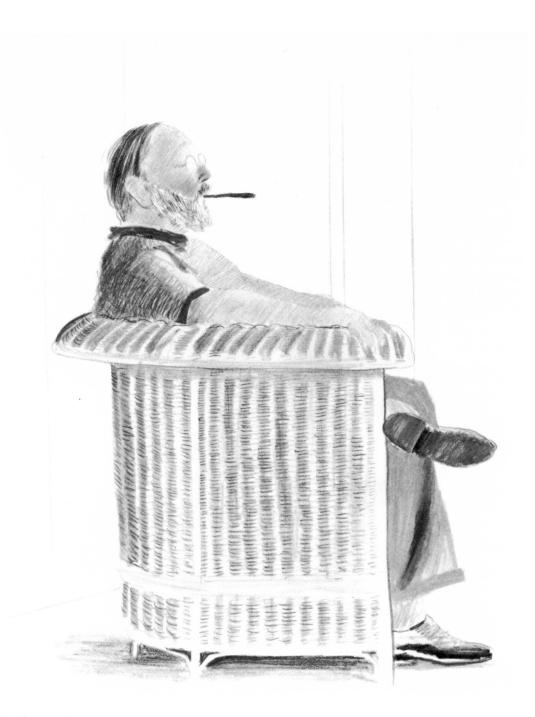

Villa Reale, Marlia (detail), 1973

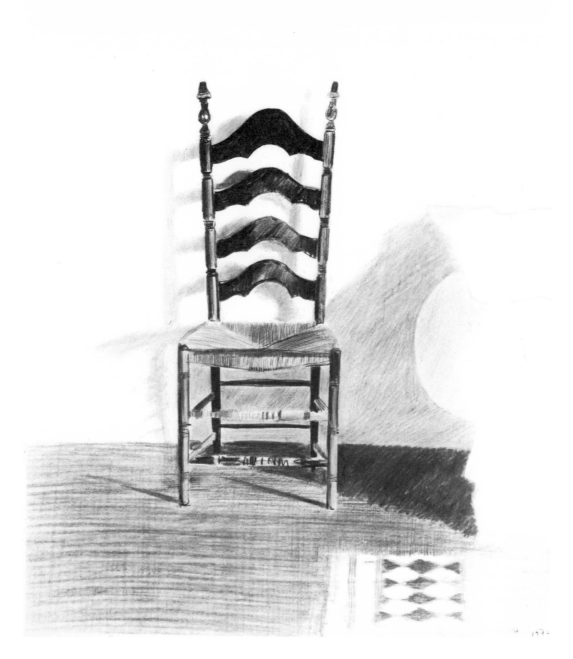

Chair, 1972

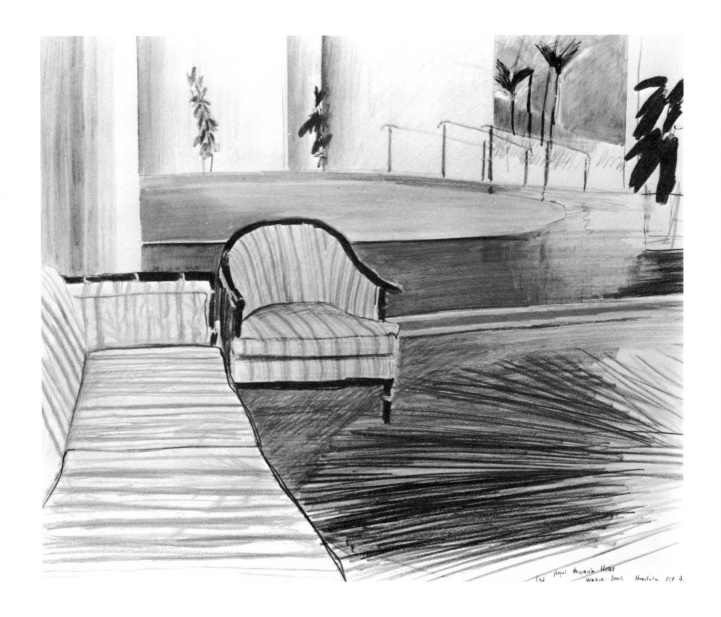

Royal Hawaiian Hotel, Honolulu, 1971

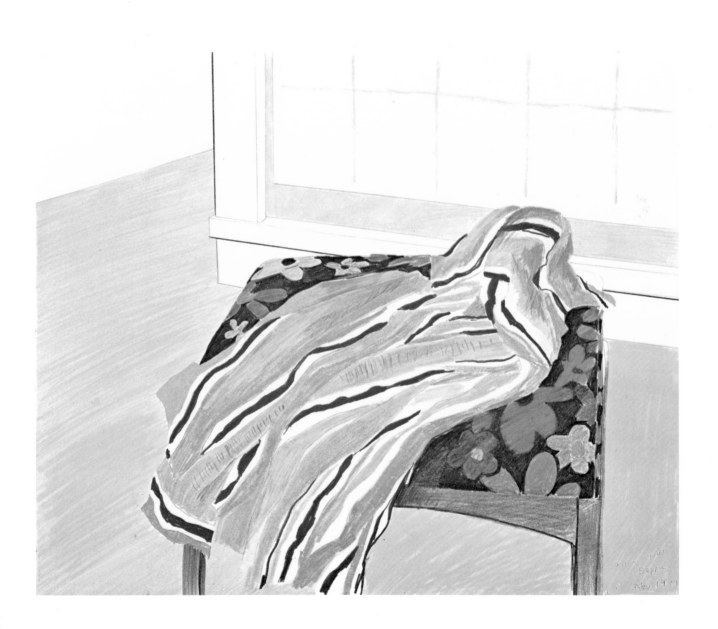

Suginoi Hotel, Beppu, 1971

Balcony, Mamounia Hotel, Marrakesh, 1971. *Crayon*, 14 x 17 inches (35.5 x 43 cm)
Window, Grand Hotel, Vittel, 1970. *Crayon*, 17 x 14 inches (43 x 35.5 cm)
Landscape in Provence, 1969. *Crayon*, 14 x 17 inches (35.5 x 43 cm)
Oriental Hotel, Bangkok, 1971. *Crayon*, 17 x 14 inches (43 x 35.5 cm)
Beach Umbrella, Calvi, 1972. *Crayon*, 17 x 14 inches (43 x 35.5 cm)
Nice, 1968. *Crayon*, 14 x 17 inches (35.5 x 43 cm)
Mountain Landscape, Lebanon, 1966. *Crayon*, 15.75 x 19.5 inches (40 x 50 cm)
Grass and Clouds, 1964. *Crayon*, 19 x 12 inches (47 x 30 cm)
Shop, Calvi, 1964. *Crayon*, 14 x 17 inches (35.5 x 43 cm)
Kyoto, 1971. *Crayon*, 14 x 17 inches (35.5 x 43 cm)

1 'I had fallen in love with Europe again in 1967; it had been four or five years since I travelled around. I'd been so full of America for five years, but coming back to Europe you realise it's certainly more interesting to drive round than America. America's wonderful as landscape, but every time you pull into a restaurant you know what the menu's going to be.'
2 'The thing is I love glamour places. I love going to places that have glamour. So any place that's new for me is good. I like to travel and now I'm all the time toying with the idea of going East to see Japan. It's building up in my mind and when it gets strong I'll just go.'

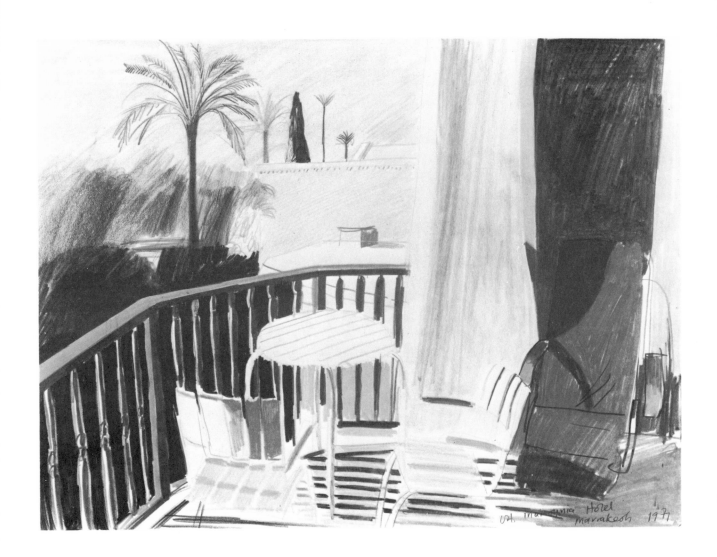

Balcony, Mamounia Hotel, Marrakesh, 1971

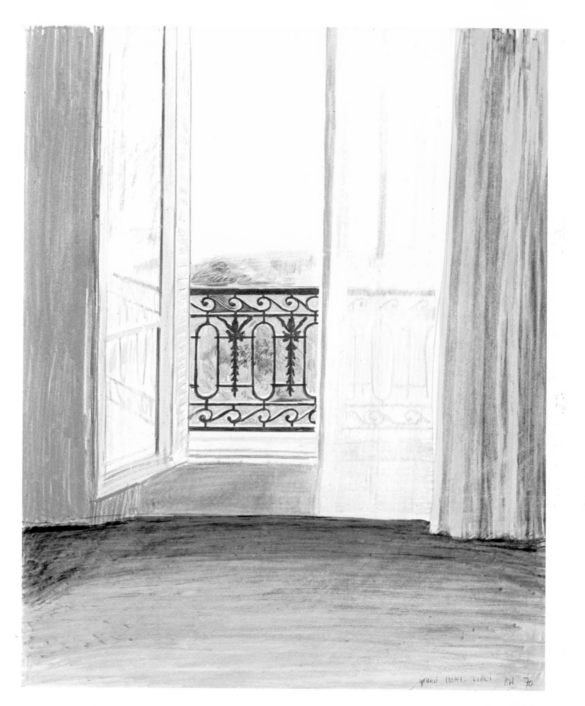

Window, Grand Hotel, Vittel, 1970

Landscape in Provence, 1969

Oriental Hotel, Bangkok, 1971

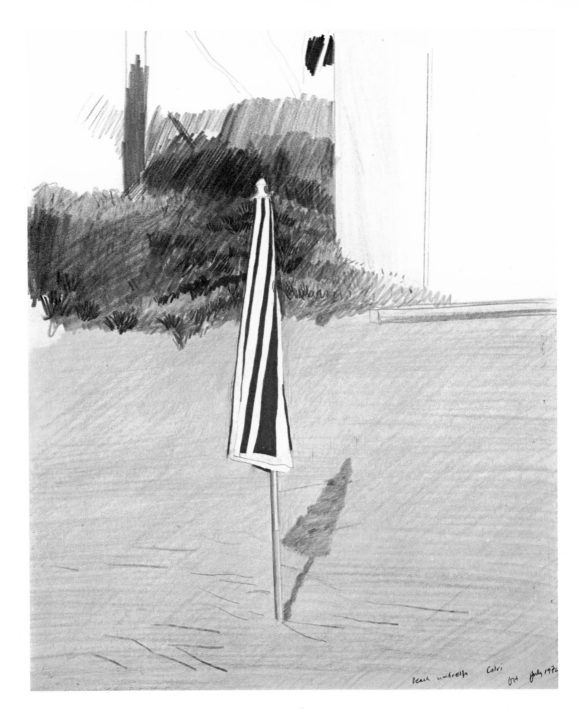

Beach Umbrella, Calvi, 1972

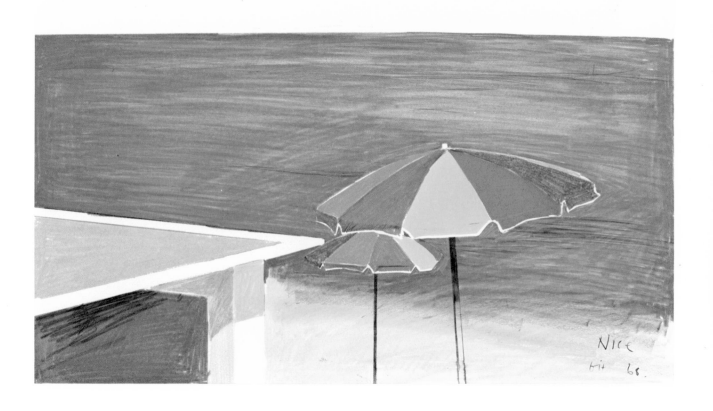

Nice, 1968

Mountain Landscape, Lebanon, 1966

Grass and Clouds, 1964

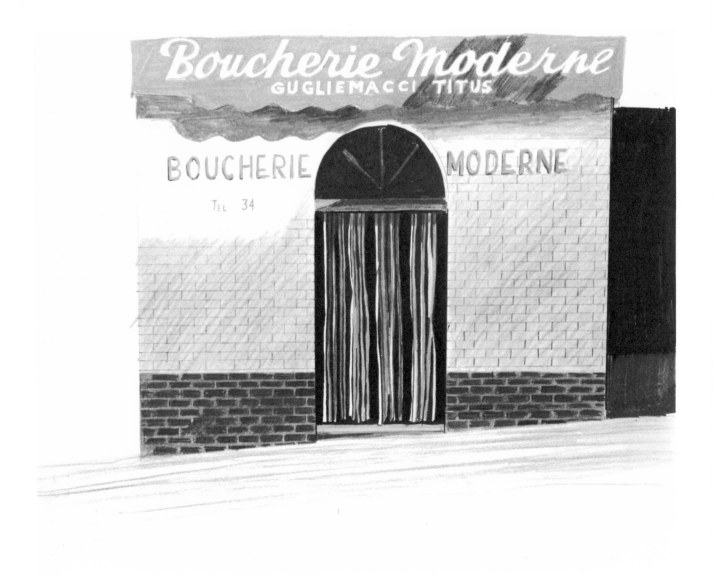

Shop, Calvi, 1964

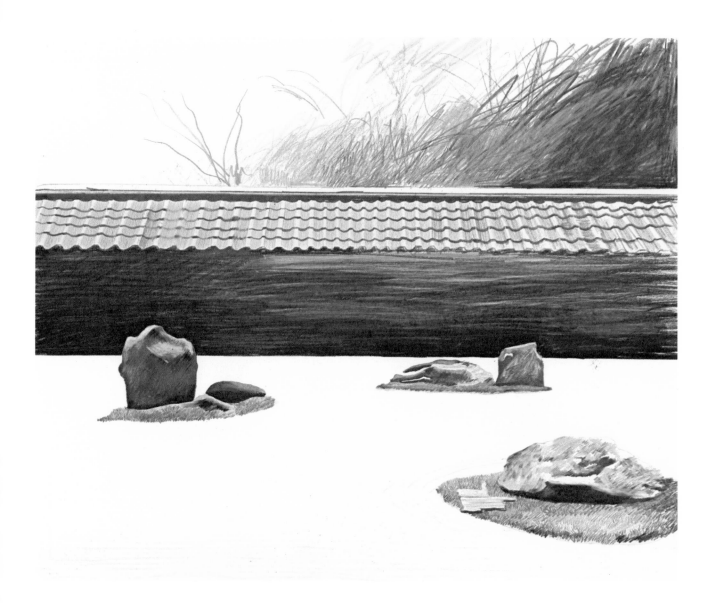

Kyoto, 1971

Gary Farmer, 1972. *Crayon*, 17 x 14 inches (43 x 35.5 cm)
The Artist's Mother, 1972. *Crayon*, 17 x 14 inches (43 x 35.5 cm)
Yves Marie Reading, 1974. *Crayon*, 17 x 14 inches (43 x 35.5 cm)
Nicky Rea, 1975. *Crayon*, 25.5 x 19.75 inches (65 x 50 cm)
Ossie Wearing a Fairisle Sweater, 1970. *Crayon*, 17 x 14 inches (43 x 35.5 cm)
Yves Marie, Paris, 1975. *Crayon*, 21 x 15.5 inches (53 x 39.5 cm)
Joe McDonald, 1975. *Crayon*, 17 x 14 inches (43 x 35.5 cm)
Nick, Grand Hotel, Calvi, 1972. *Crayon*, 17 x 14 inches (43 x 35.5 cm)
Dr Eugen Lamb, 1973. *Crayon*, 17 x 14 inches (43 x 35.5 cm)
Mark, Suginoi Hotel, Beppu, 1971. *Crayon*, 17 x 14 inches (43 x 35.5 cm)

'The thing Cezanne says, about the figure being just a cone, a cylinder and a sphere: well, it isn't. His remark meant something at the time, but we know a figure is really more than that, and more will be read into it. To say it is just that means you would reject a great deal of Renaissance painting; this is what it's all about; it *is* that. You cannot escape sentimental – in the best sense of the term – feelings and associations from the figure, from the picture, it's inescapable. Because Cezanne's remark is famous – it was thought of as a key attitude in modern art – you've got to face it and answer it.'

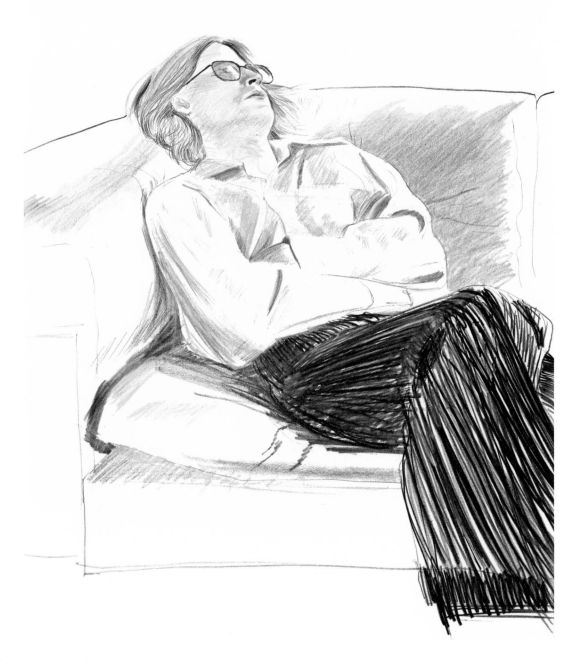

Gary Farmer, 1972

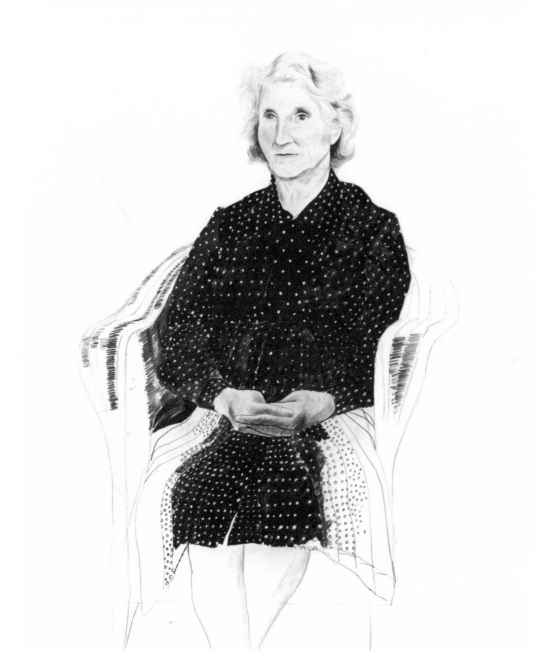

The Artist's Mother, 1972

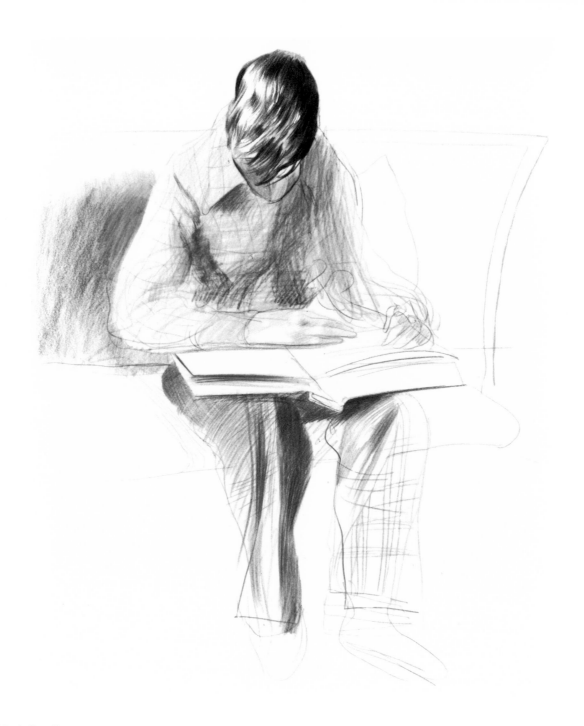

Yves Marie Reading, 1974

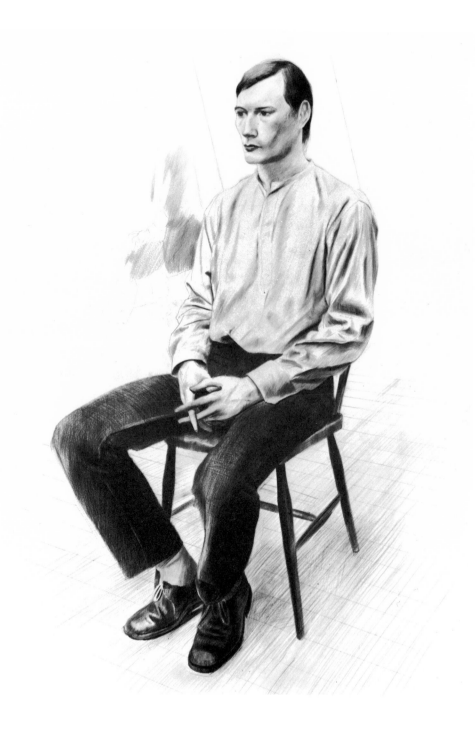

Nicky Rea, 1975

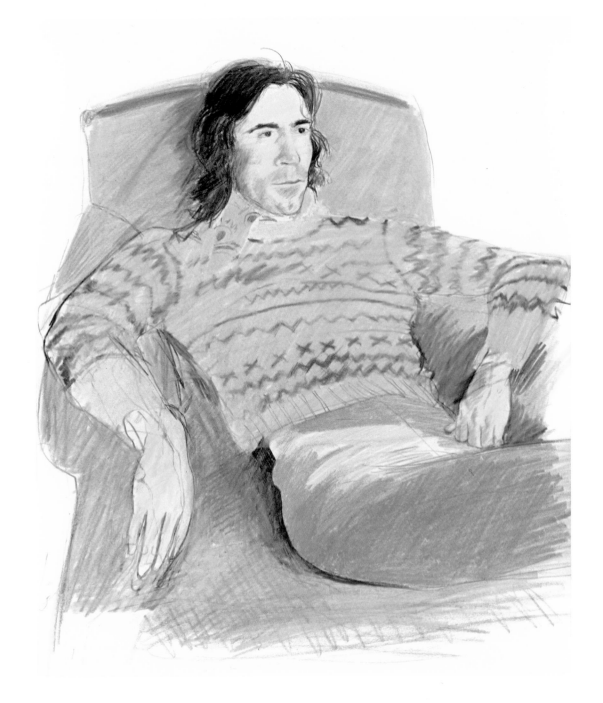

Ossie Wearing a Fairisle Sweater, 1970

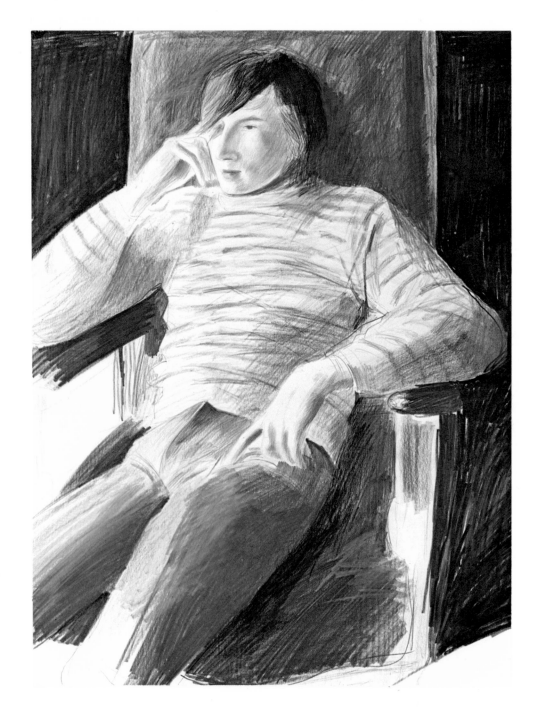

Yves Marie, Paris, 1975

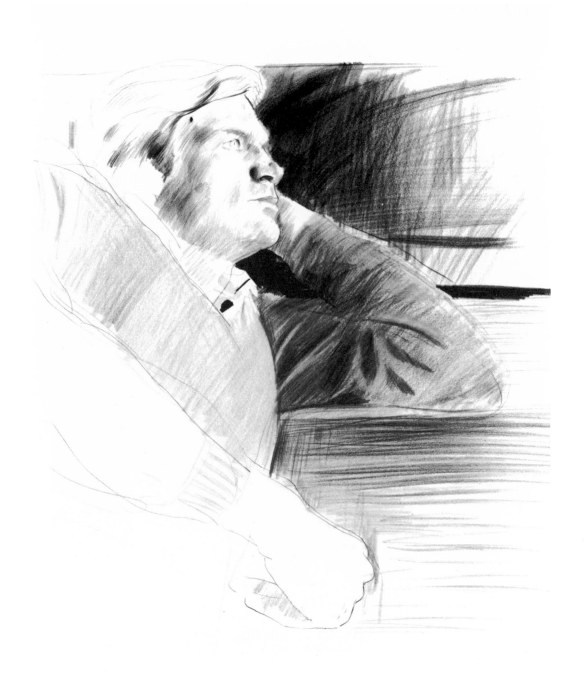

Joe McDonald, 1975

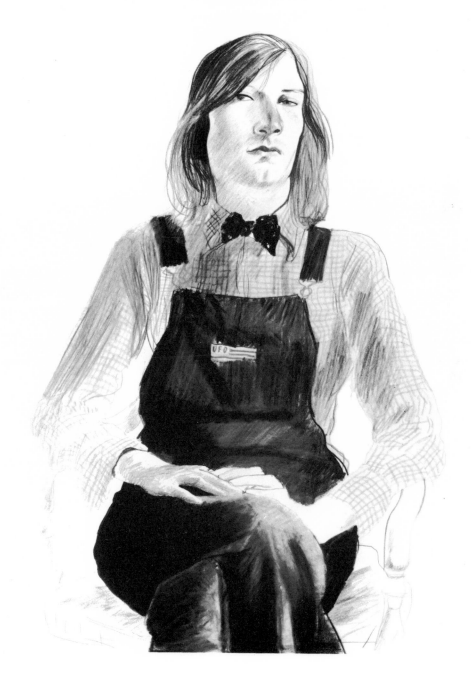

Nick, Grand Hotel, Calvi, 1972

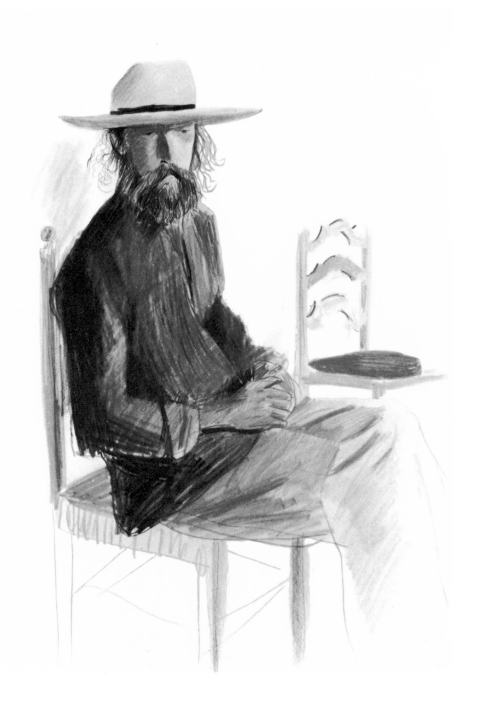

Dr Eugen Lamb, 1973

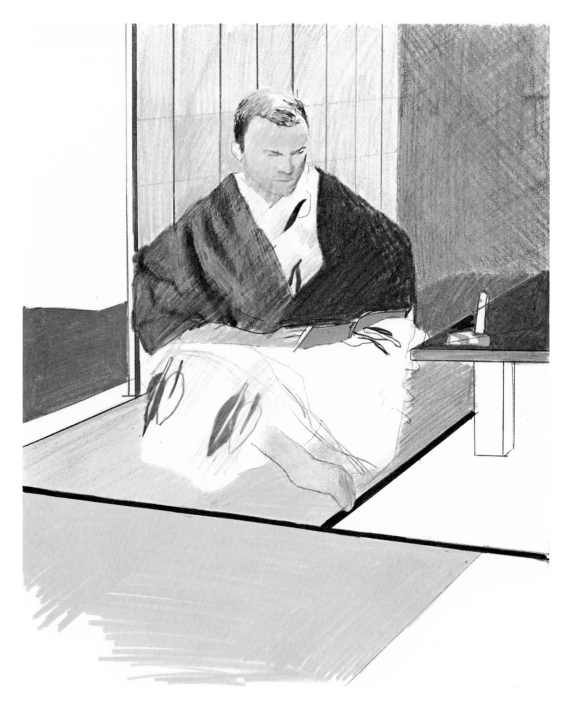

Mark, Suginoi Hotel, Beppu, 1971

Drawing of a Pool and Towel, 1971. *Crayon*, 17 x 14 inches (43 x 35.5 cm)
Rain, 1973. *Lithograph*, 39 x 32 inches (99 x 81 cm)
Striped Water, 1965. *Crayon*, 13.75 x 16.5 inches (35 x 42 cm)
Water Entering Swimming Pool, Santa Monica, 1964. *Crayon*, 11 x 14 inches (27.5 x 35.5 cm)
Study of Water, Phoenix, Arizona, 1976. *Crayon*, 16 x 19.75 inches (40.5 x 50 cm)
Palm Reflected in Pool, Arizona, 1976. *Crayon*, 19.75 x 16 inches (50 x 40.5 cm)
Don Factor's Swimming Pool, Beverly Hills, 1966. *Crayon*, 14 x 17 inches (35.5 x 43 cm)
Hollywood Pool and Palm Tree, 1965. *Crayon*, 12.5 x 17 inches (32 x 43 cm)
Lawn Sprinkler, 1966. *Crayon*, 14 x 17 inches (35.5 x 43 cm)
Swimming Pool and Garden, Beverly Hills, 1965. *Pencil and crayon*, 19 x 24 inches (48.5 x 61 cm)

1 'It is a formal problem to represent water, to describe water, because it can be anything –
it can be any colour, it's movable, it has no set visual description.'

2 'Water in swimming pools changes its look more than in any other form. The colour of a
river is related to the sky it reflects, and the sea always seems to me to be the same colour
and have the same dancing patterns. But the swimming-pool water is controllable – even its
colour can be man-made – and its dancing rhythms reflect not only the sky but, because of its
transparency, the depth of the water as well. If the water surface is almost still and there is a
strong sun, then dancing lines with the colours of the spectrum appear everywhere. If the
pool hasn't been used for a few minutes and there's no breeze, the look is of a simple grad-
ation of colour that follows the incline of the floor of the pool. Added to all this is the
infinite variety of patterns of material that the pool can be made from.'

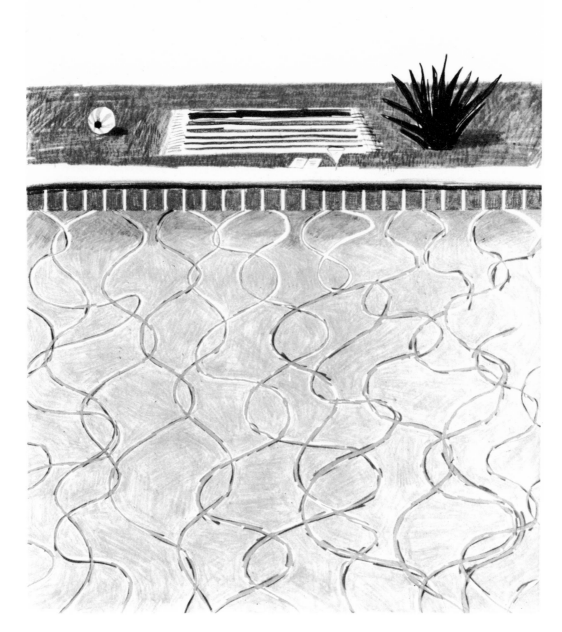

Drawing of a Pool and Towel, 1971

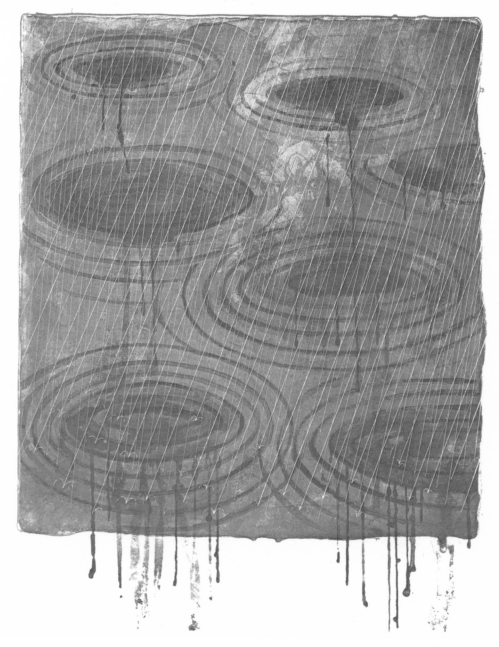

rain

Rain, 1973

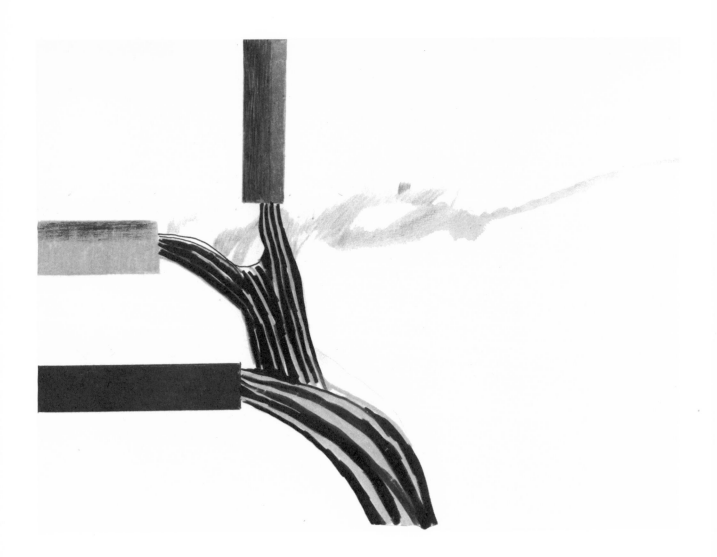

Striped Water, 1965

Water Entering Swimming Pool, Santa Monica, 1964

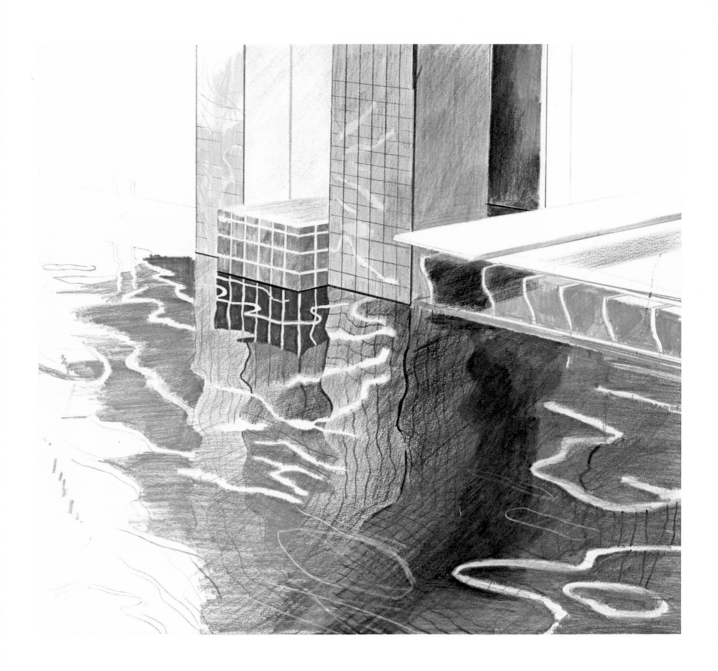

Study of Water, Phoenix, Arizona, 1976

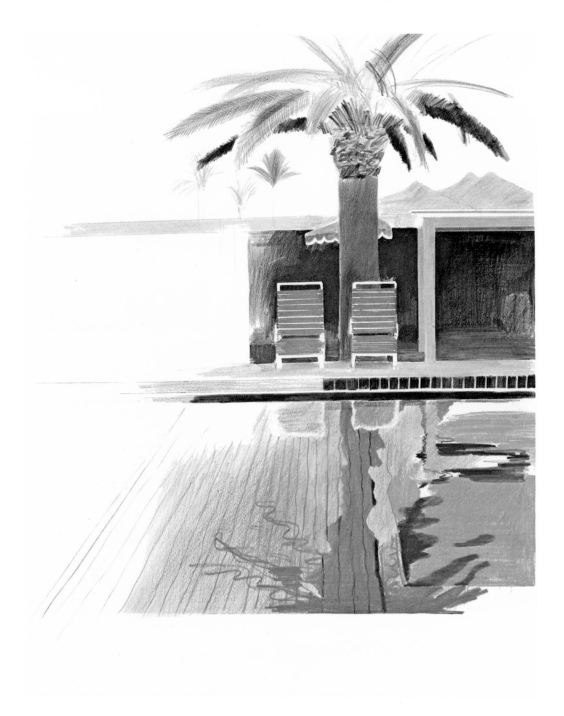

Palm Reflected in Pool, Arizona, 1976

Don Factor's Swimming Pool, Beverly Hills, 1966

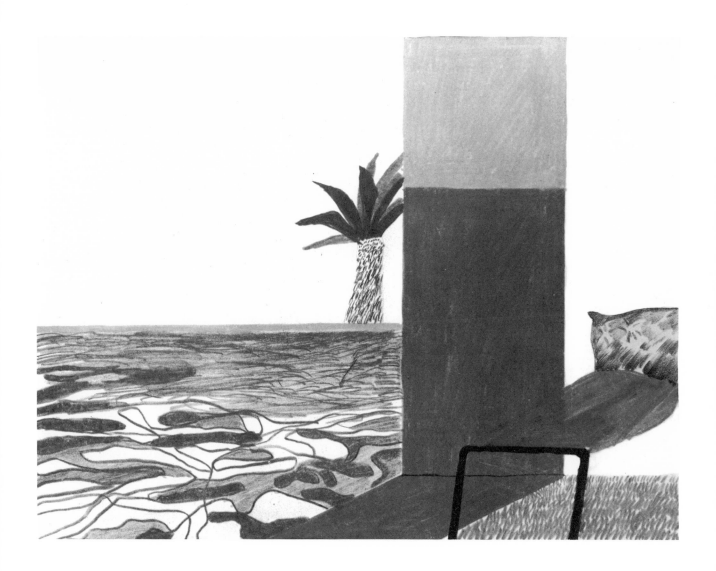

Hollywood Pool and Palm Tree, 1965

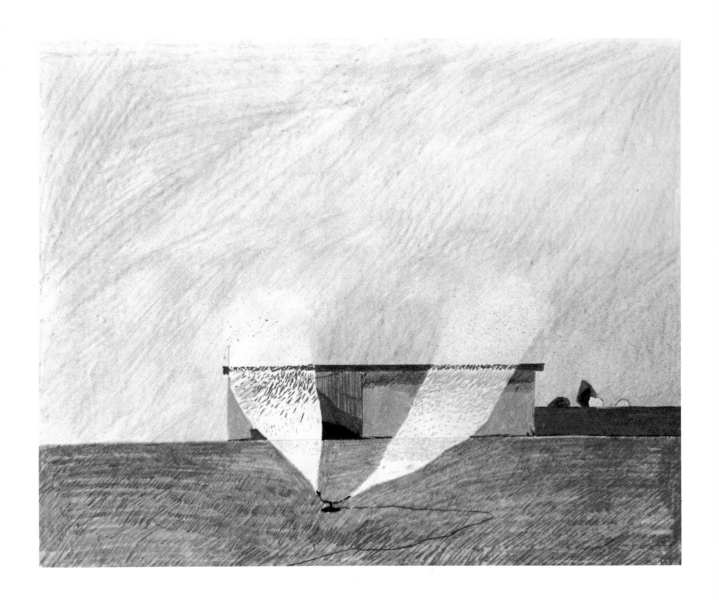

Lawn Sprinkler, 1966

Swimming Pool and Garden, Beverly Hills, 1965

Gregory, 1974. *Etching*, 36.25 x 28.5 inches (92 x 72 cm)
The Master Printer of Los Angeles, 1973. *Lithograph*, 48 x 32 inches (122 x 81 cm)
The Marriage, 1962. *Etching and aquatint*, 12 x 15.75 inches (30.5 x 40 cm)
Jungle Boy, 1964. *Etching*, 15.75 x 19.25 inches (40 x 49 cm)
Rue de Seine, 1972. *Etching and aquatint*, 27 x 21 inches (68 x 54 cm)
Two Vases in the Louvre, 1974. *Etching and aquatint*, 39 x 35.5 inches (99 x 90 cm)
The Diploma, 1962. *Etching and aquatint*, 16 x 11 inches (40.5 x 28 cm)
Artist and Model, 1974. *Etching and aquatint*, 32 x 24 inches (81 x 61 cm)
Flowers and Vase, 1969. *Etching and aquatint*, 28 x 22 inches (70 x 55 cm)
Sun, 1973. *Lithograph*, 37 x 31 inches (94 x 77 cm)

1 'I'm not a printmaker, I'm a painter who makes a few prints. The point about etching is that you have to know how to draw; it's basically a linear medium.'

2 'Aldo asked me Why don't you do any coloured etching? I said I'd thought of it, but it was so difficult to do. To register the colour, you have to use two or three plates; you have to make a drawing to begin with in colour. And I said, It seems to me the whole point about etching is that it can be a spontaneous medium; you can just start a plate and begin drawing anything. You don't need a drawing at the side of you – you can work from life, anything, in black and white. And Aldo said Ah, that's exactly what Picasso said about coloured etchings; he didn't really want to get involved, it was too elaborate, and you lost the spontaneity. And then he said, I thought of a method where you can be spontaneous.'

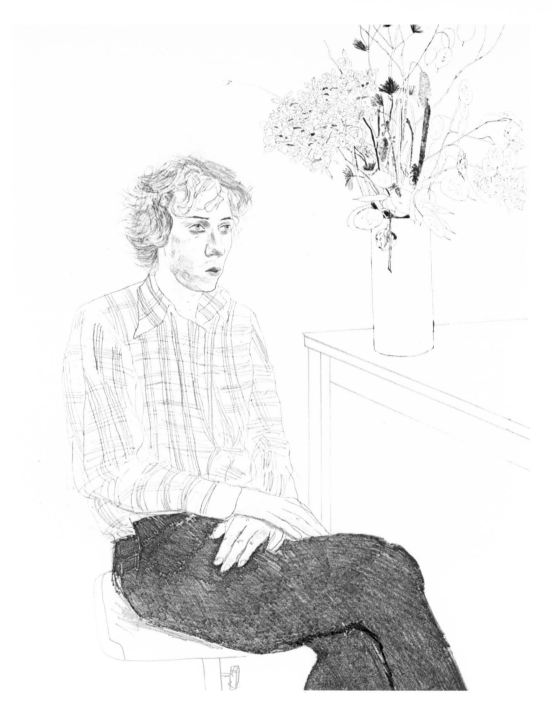

Gregory, 1974

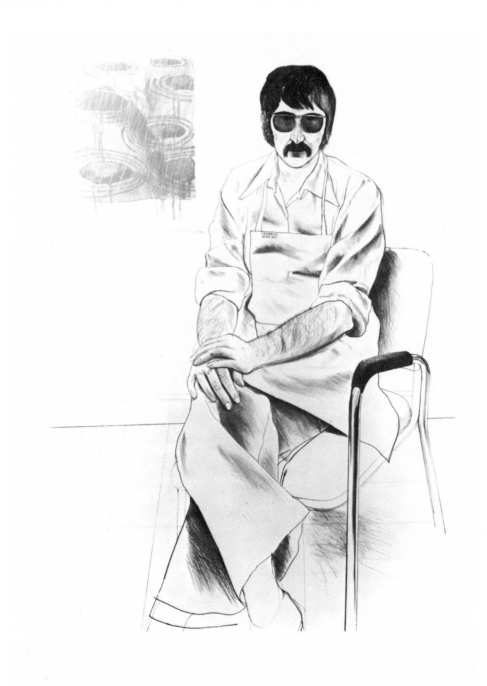

The Master Printer of Los Angeles, 1973

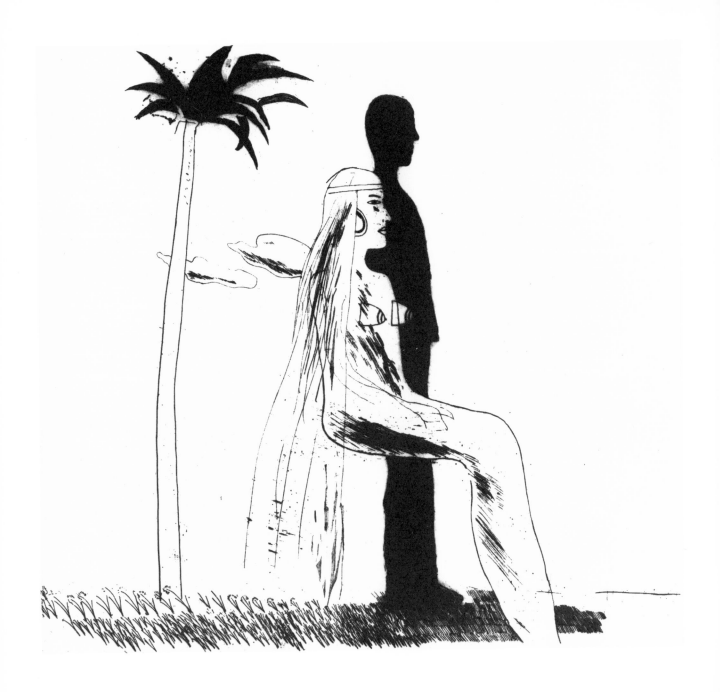

The Marriage, 1962

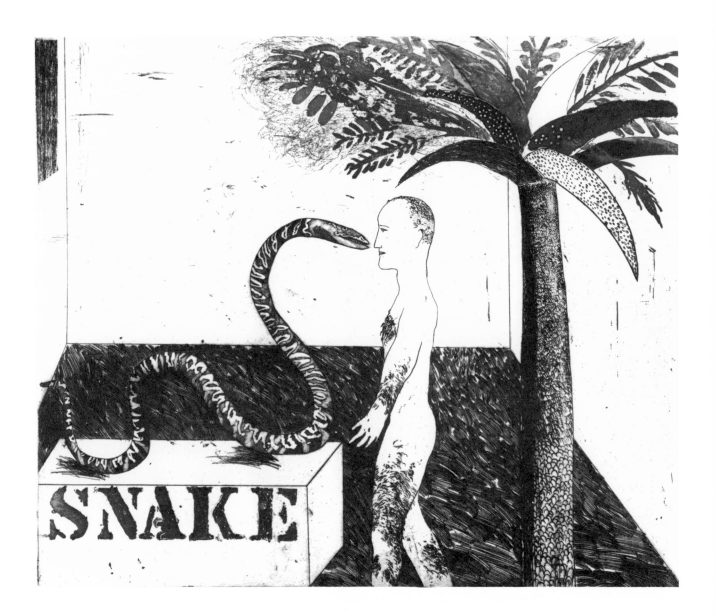

Jungle Boy, 1964

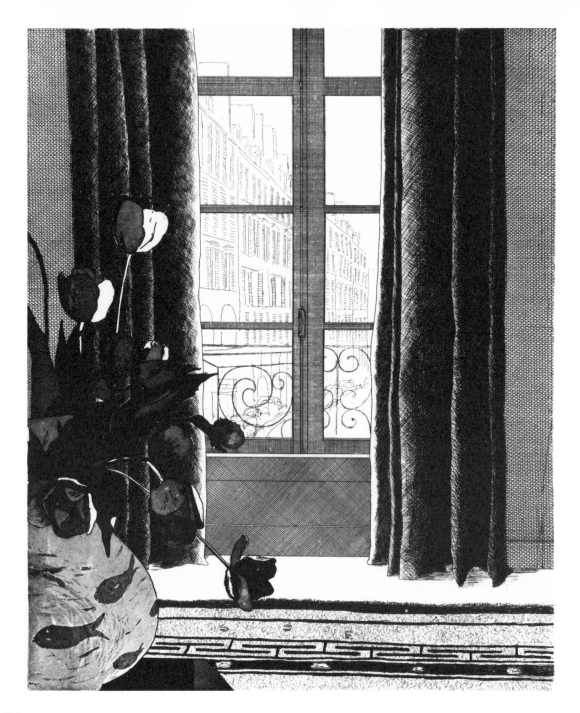

Rue de Seine, 1972

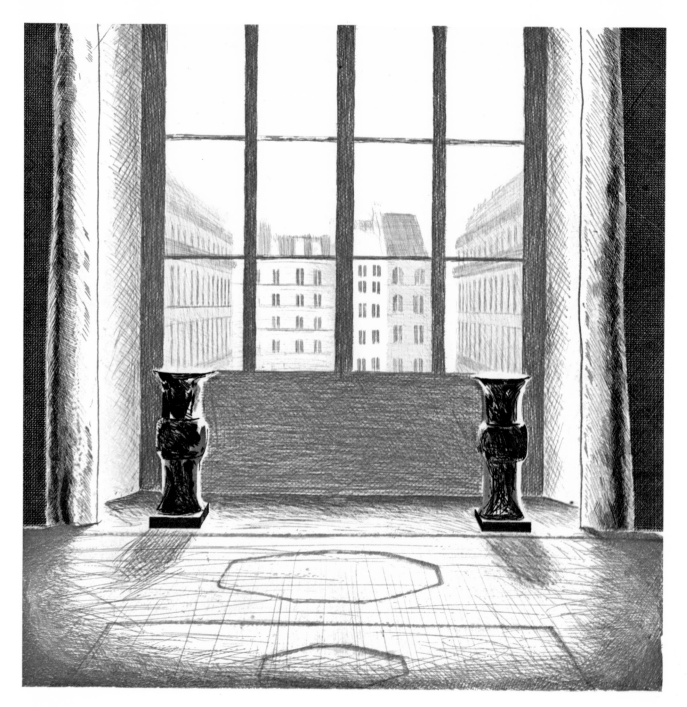

Two Vases in the Louvre, 1974

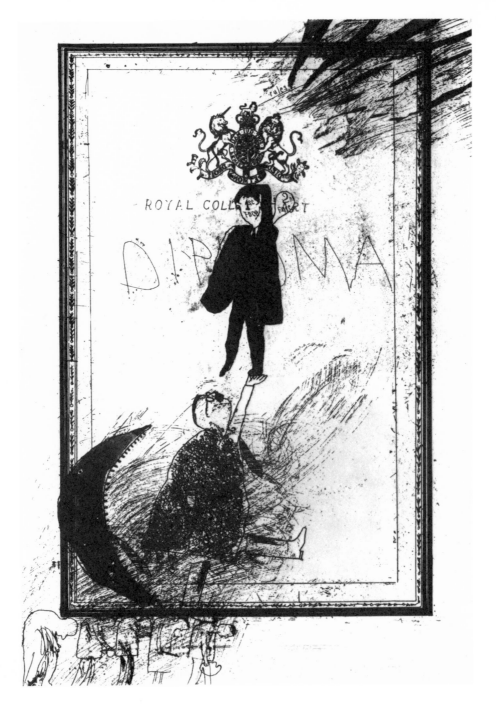

The Diploma, 1962

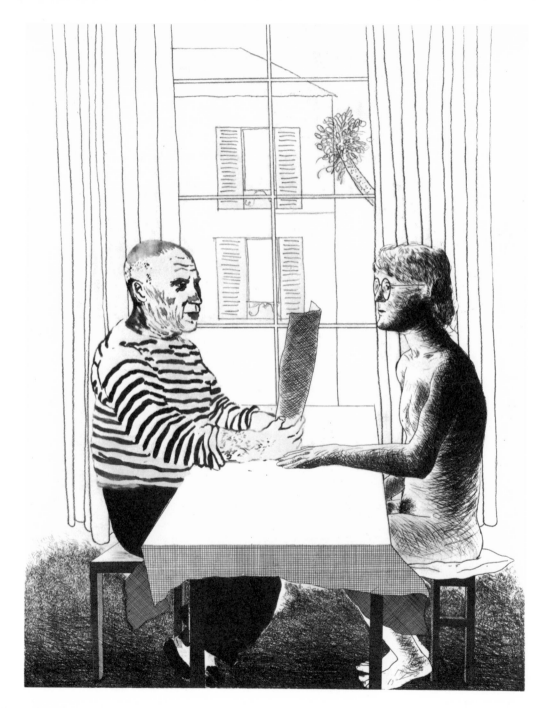

Artist and Model, 1974

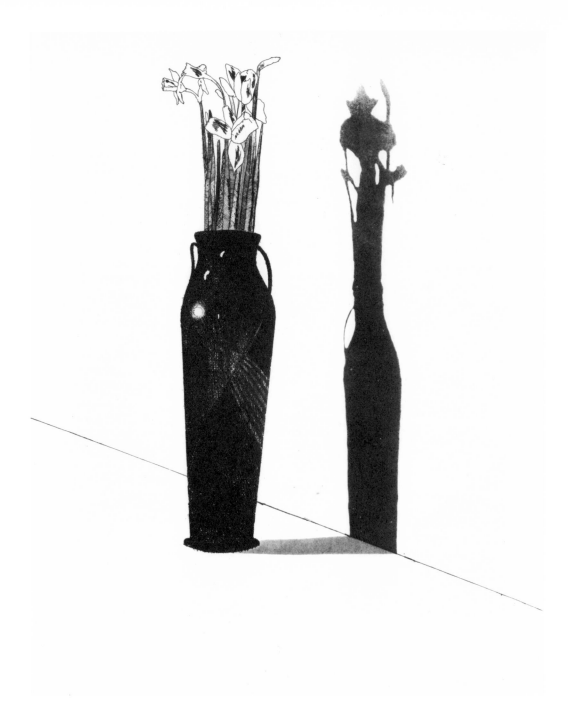

Flowers and Vase, 1969

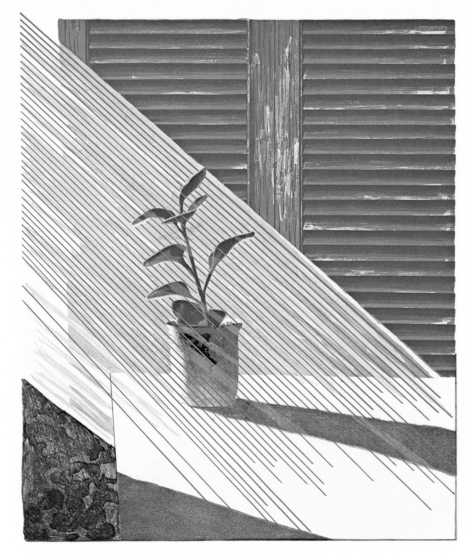

Sun, 1973

Peter, 1972. *Ink*, 17 x 14 inches (43 x 35.5 cm)
Kasmin in India, 1977. *Ink*, 14 x 17 inches (35.5 x 43 cm)
Clive Barker, 1975. *Ink*, 17 x 14 inches (43 x 35.5 cm)
Peter, Hotel Regina, Venice, 1970. *Ink*, 17 x 14 inches (43 x 35.5 cm)
Mo Asleep, 1971. *Etching and aquatint*, 35 x 28 inches (89 x 72 cm)
Celia Sleeping, 1972. *Ink*, 14 x 17 inches (35.5 x 43 cm)
Ossie, 1970. *Ink*, 17 x 14 inches (43 x 35.5 cm)
Mo, Paris, 1973. *Ink*, 17 x 14 inches (43 x 35.5 cm)
My Father, 1972. *Ink*, 14 x 17 inches (35.5 x 43 cm)
Maurice Sleeping, 1977. *Ink*, 14 x 17 inches (35.5 x 43 cm)

'To reduce things to line I think is really one of the hardest things. I never talk when I'm drawing a person, especially if I'm making line drawings. I prefer there to be no noise at all so I can concentrate more. You can't make a line too slowly, you have to go at a certain speed; so the concentration needed is quite strong. If you make two or three line drawings, it's very tiring in the head, because you have to do it all at one go, something you've no need to do with pencil drawings; that doesn't have to be done in one go; you can stop, you can rub out. With line drawings, you don't want to do that. You can't rub out line, mustn't do it. It's exciting doing it, and I think it's harder than anything else; so when they succeed? they're much better drawings.'

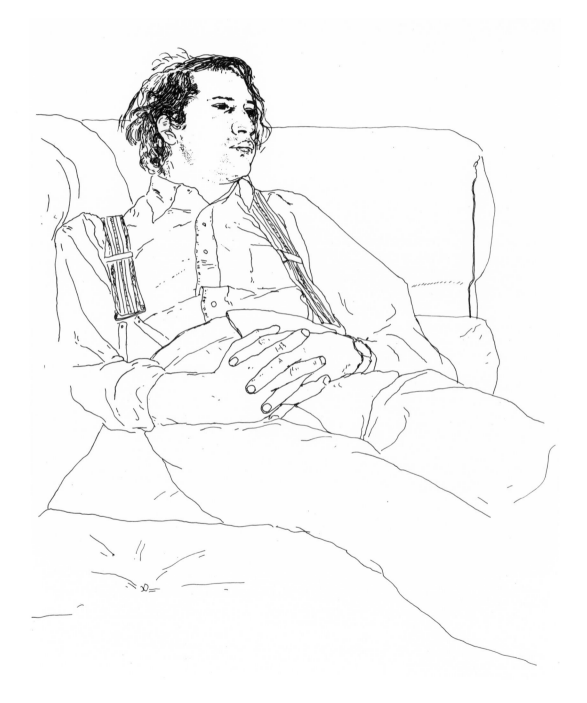

Peter, 1972

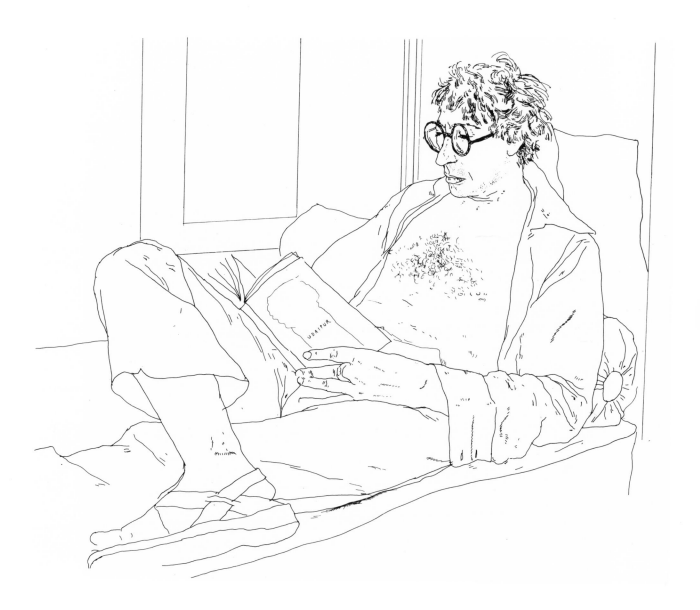

Kasmin in India, 1977

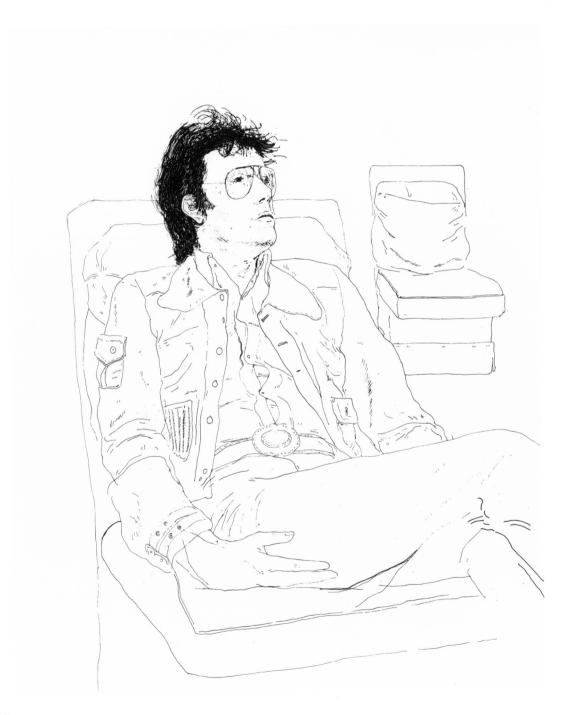

Clive Barker, 1975

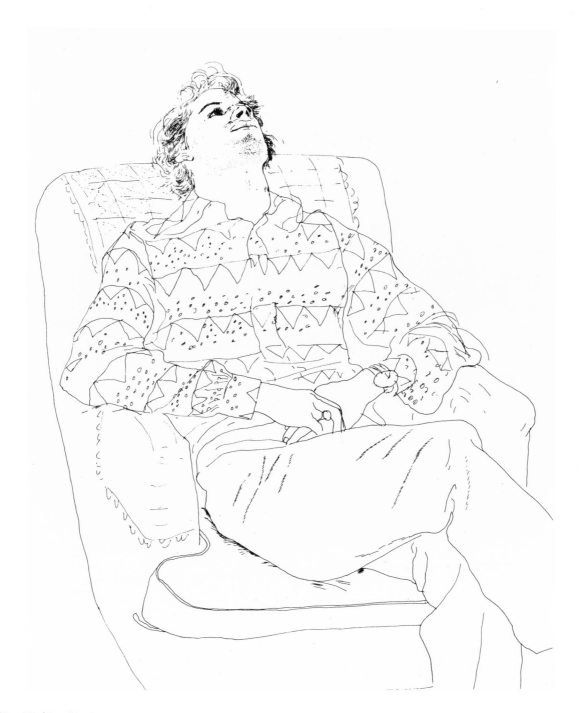

Peter, Hotel Regina, Venice, 1970

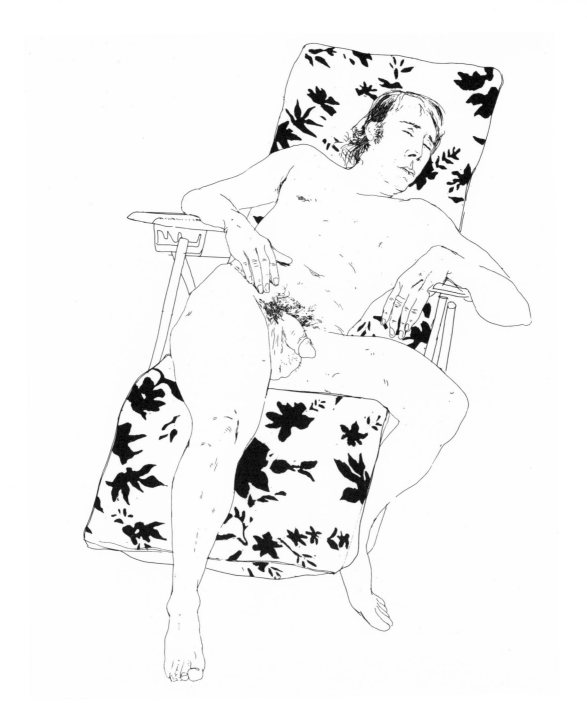

Mo Asleep, 1971

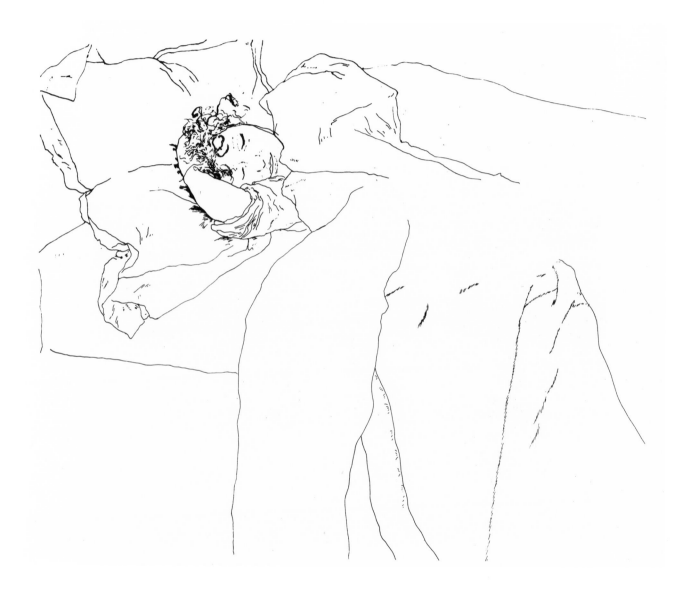

Celia Sleeping, 1972

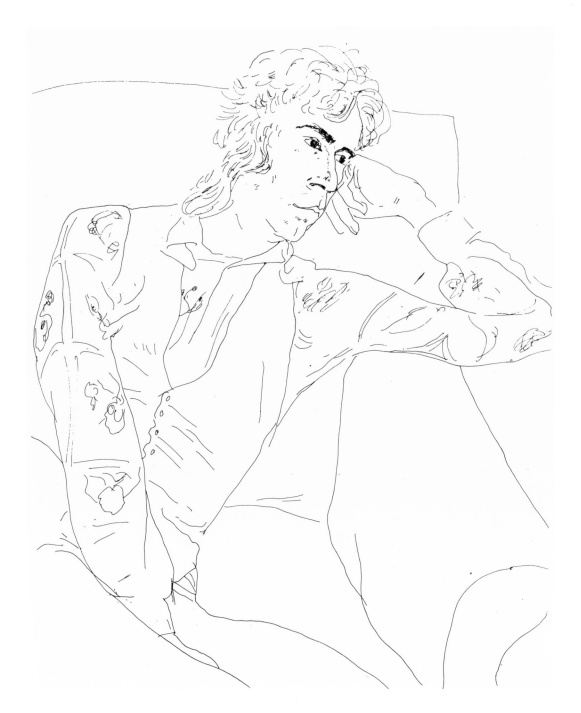

Ossie, 1970

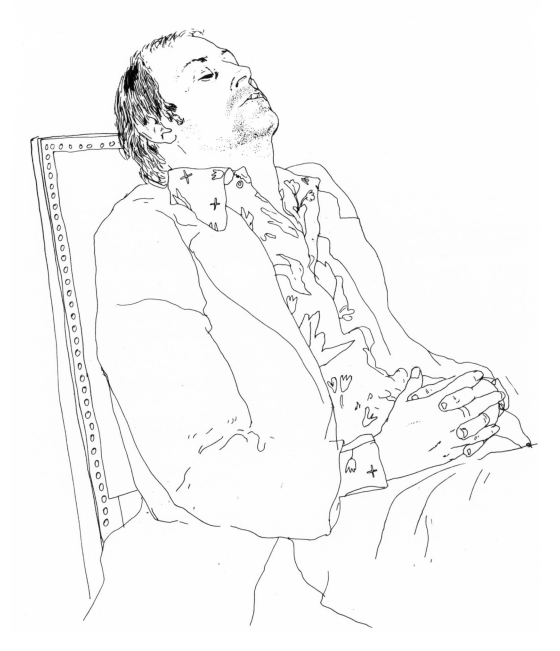

Mo, Paris, 1973

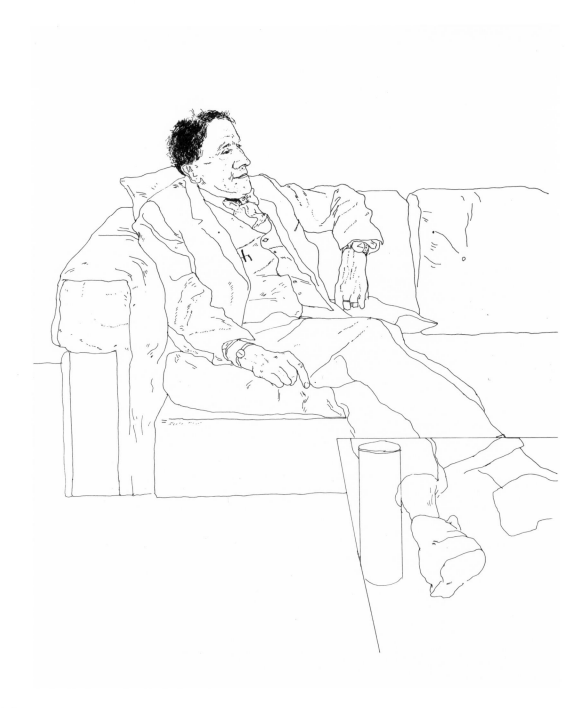

My Father, 1972

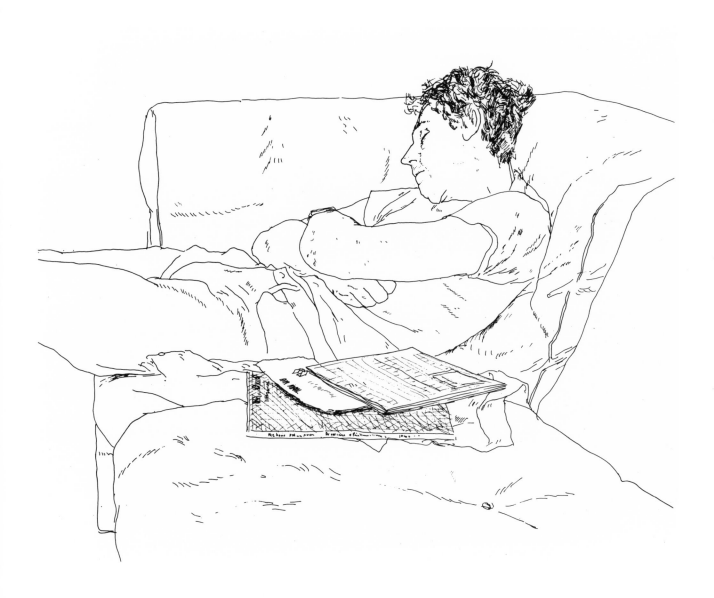

Maurice Sleeping, 1977

Small Garden, Sunset Boulevard, 1976. *Crayon*, 19.75 x 16 inches (50 x 40.5 cm)
Dark Mist, 1973. *Lithograph*, 35 x 28 inches (89 x 71 cm)
Pacific Mutual Life, 1964. *Lithograph*, 20 x 25 inches (51 x 64 cm)
Bank, Palm Springs, 1968. *Crayon*, 14 x 17 inches (35.5 x 43 cm)
Rampau Boulevard, Los Angeles, 1976. *Crayon*, 14 x 17 inches (35.5 x 43 cm)
De Longpre Avenue, Hollywood, 1976. *Crayon*, 17 x 14 inches (43 x 35.5 cm)
Hollywood Garden, 1965. *Crayon*, 19 x 23.5 inches (49 x 60 cm)
Washington Boulevard, 1964. *Crayon*, 10.5 x 13.5 inches (26.5 x 34 cm)
3rd Street, Santa Monica, 1968. *Crayon*, 17 x 14 inches (43 x 35.5 cm)
1059 Baboa Boulevard, 1967. *Crayon*, 14 x 17 inches (35.5 x 43 cm)

1 'California did affect me very strongly. I first went there at the end of 1963 with the intention of staying for six months to paint. Somehow I instinctively knew that I was going to like it. And as I flew over San Bernardino and looked down – and saw the swimming pools and the houses and everything and the sun, I was more thrilled than I've ever been arriving at any other city, including New York.'

2 'Within a week of arriving there in this strange big city, not knowing a soul, I'd passed the driving test, bought a car, driven to Las Vegas and won some money, got myself a studio, started painting, all in a week. And I thought, it's just how I imagined it would be.'

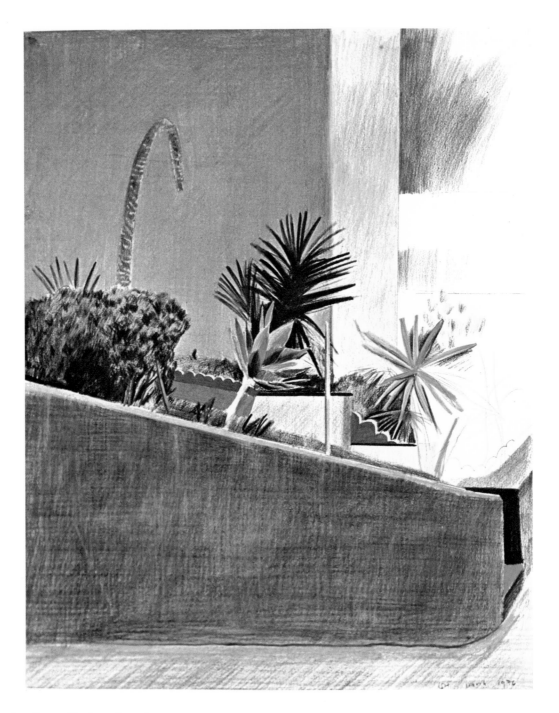

Small Garden, Sunset Boulevard, 1976

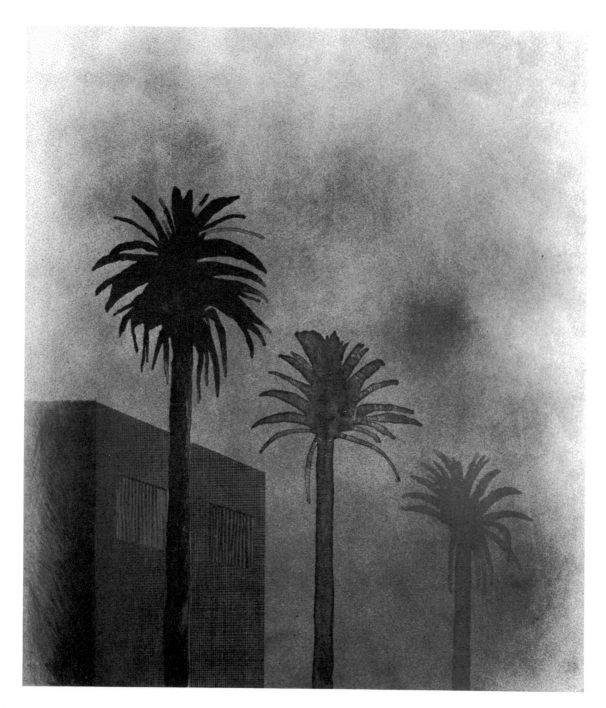

Dark Mist, 1973

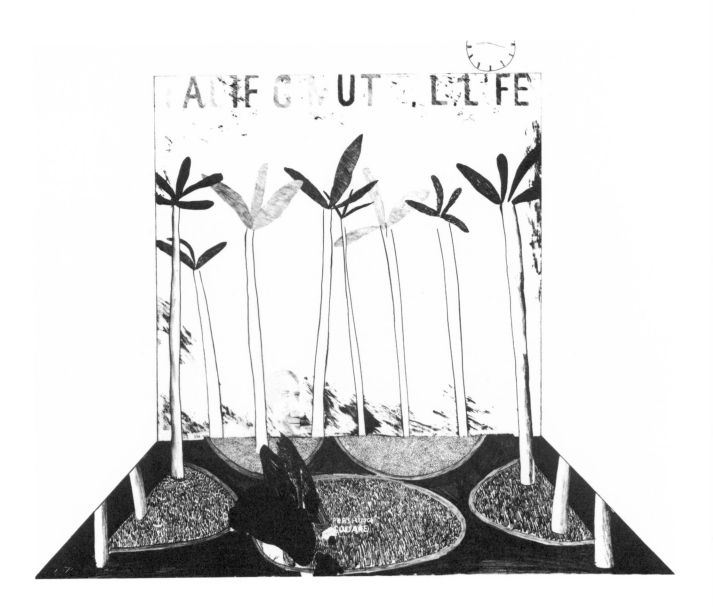

Pacific Mutual Life, 1964

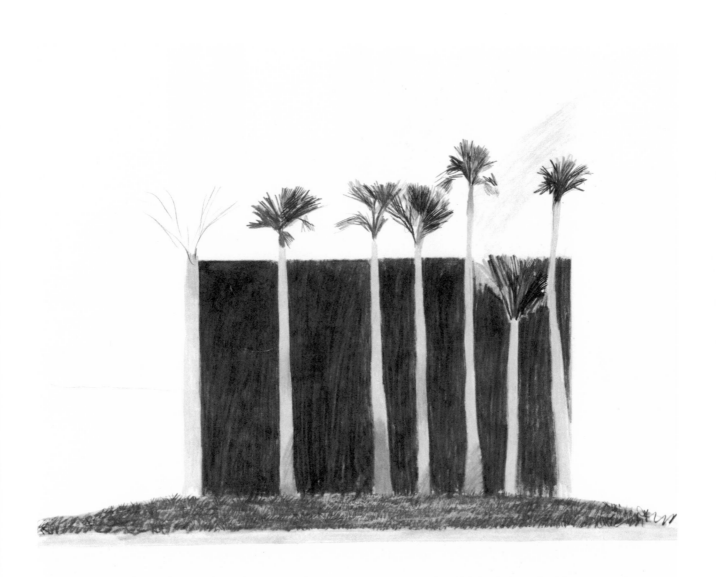

Bank, Palm Springs, 1968

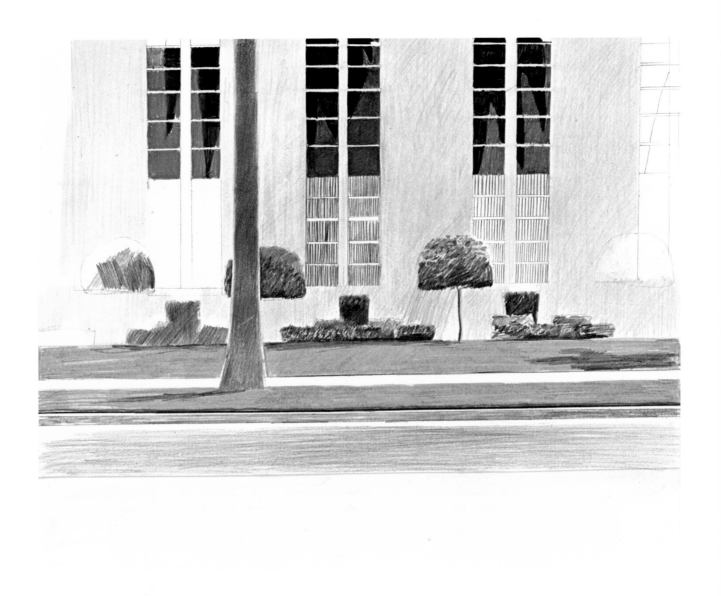

Rampau Boulevard, Los Angeles, 1976

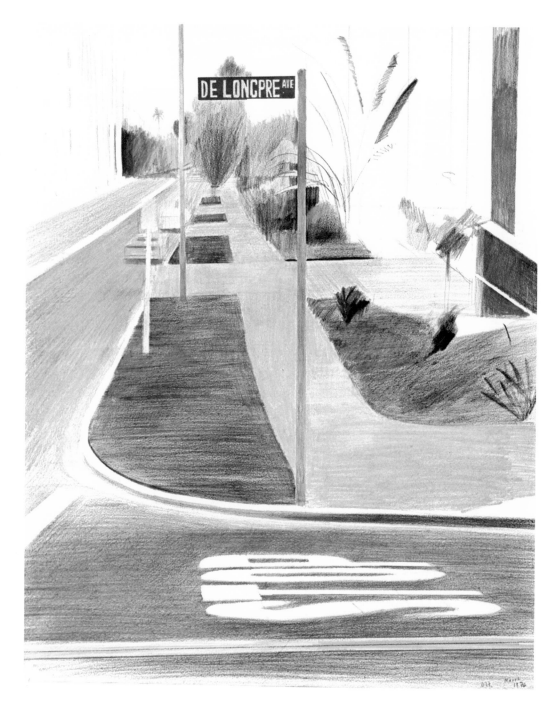

De Longpre Avenue, Hollywood, 1976

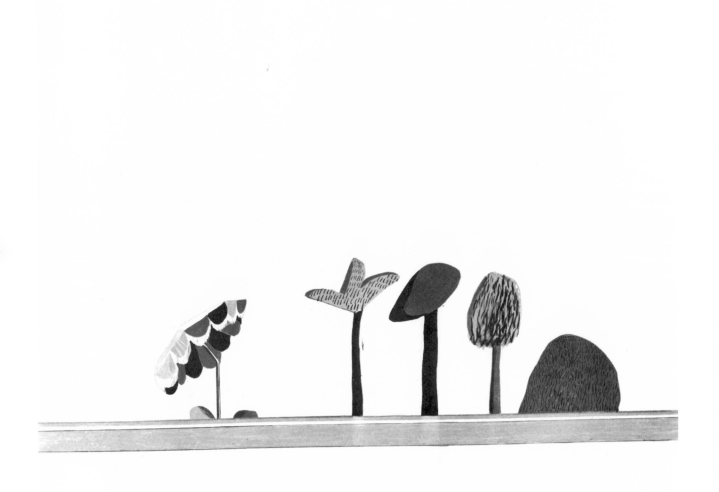

Hollywood Garden, 1965

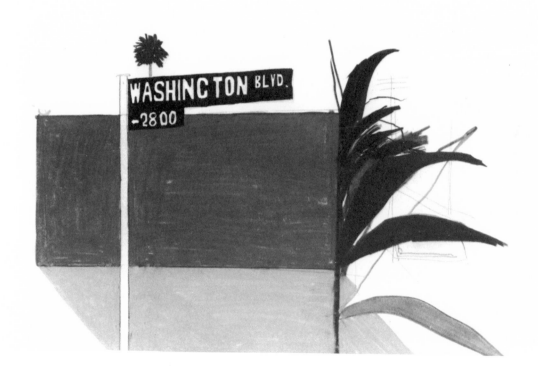

Washington Boulevard, 1964

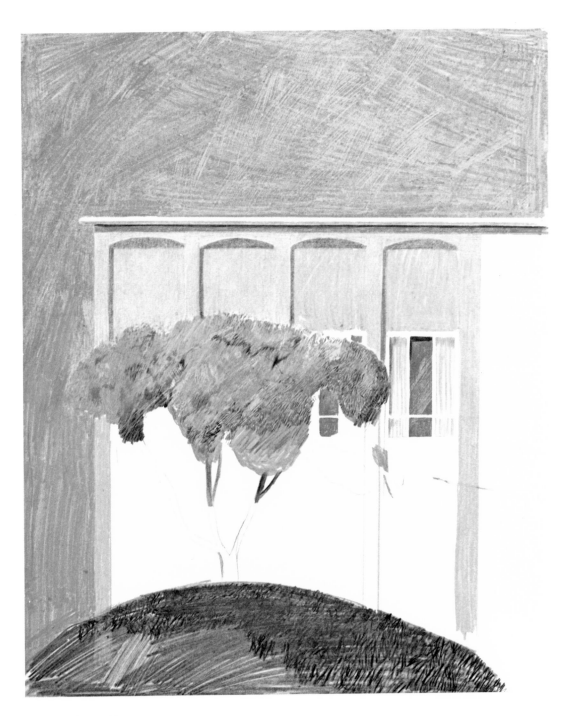

3rd Street, Santa Monica, 1968

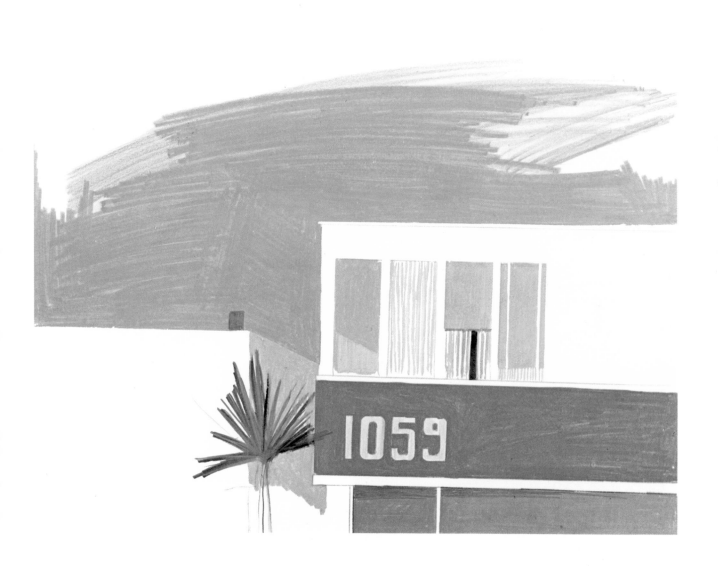

1059 Baboa Boulevard, 1967

Skittle Stood in Front of a Picture of a Man Jumping, 1963. *Pencil and crayon*, 20 x 23.5 inches (51 x 59 cm)
Carennac, 1970. *Ink*, 14 x 17 inches (35.5 x 43 cm)
Postcard of Richard Wagner with a Glass of Water, 1973. *Etching*, 8 x 6 inches (21 x 15 cm)
Mirror, Casa Santini, 1973. *Crayon*, 17 x 14 inches (43 x 35.5 cm)
Banana, 1970. *Crayon*, 17 x 14 inches (43 x 35.5 cm)
Leeks, 1970. *Crayon*, 14 x 17 inches (35.5 x 43 cm)
Park Hotel, Munich, 1972. *Crayon*, 17 x 14 inches (43 x 35.5 cm)
Flower Still Life, 1975. *Ink*, 14 x 17 inches (35.5 x 43 cm)
Sony TV, 1968. *Crayon*, 17 x 14 inches (43 x 35.5 cm)
Hotel Room, Hot Springs, Arkansas, 1976. *Crayon*, 14 x 17 inches (35.5 x 43 cm)

1 'I had found that anything could become a subject of a painting: a poem, something you see, an idea you suddenly have, something you feel – anything was material you could use.'

2 'I'd become interested in the still life or the arrangements of still life. The idea grew from the curtain motif of previous pictures. The reasoning went something like this: curtains are associated with theatricality; visually the theatre is an arrangement on a stage of figures and objects; the traditional still-life painting in art schools (based on Cezanne) is usually an arrangement of apples and vases or wine bottles on a tablecloth, perhaps a curtain in repose. Remembering that Cezanne had said everything can be reduced to a cone, I conceived the idea of inventing some still lifes.'

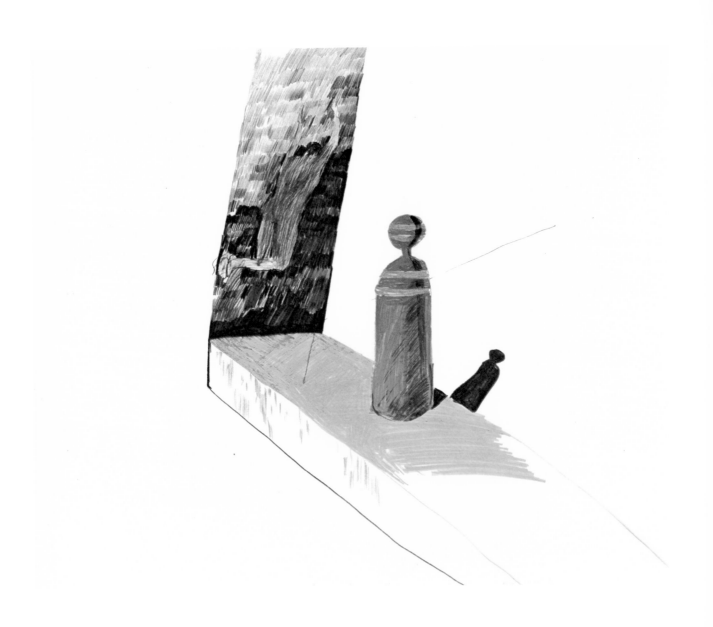

Skittle Stood in Front of a Picture of a Man Jumping, 1963

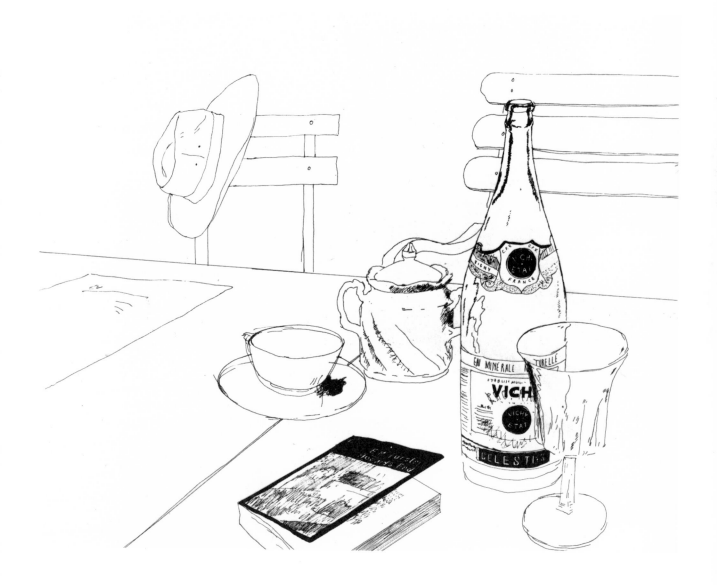

Carennac, 1970

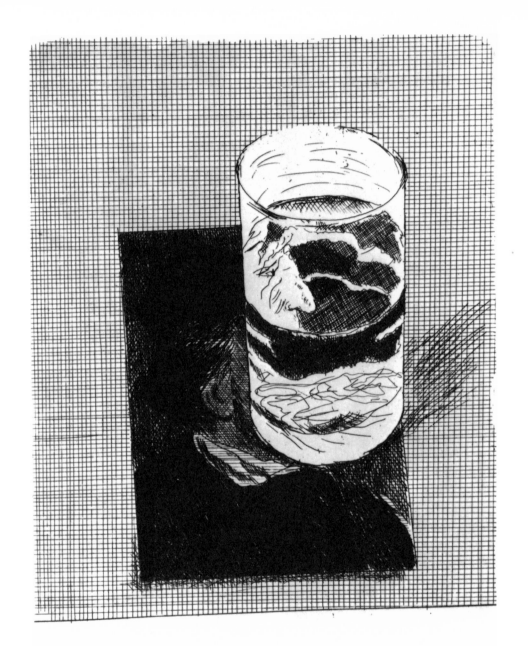

Postcard of Richard Wagner with a Glass of Water, 1973

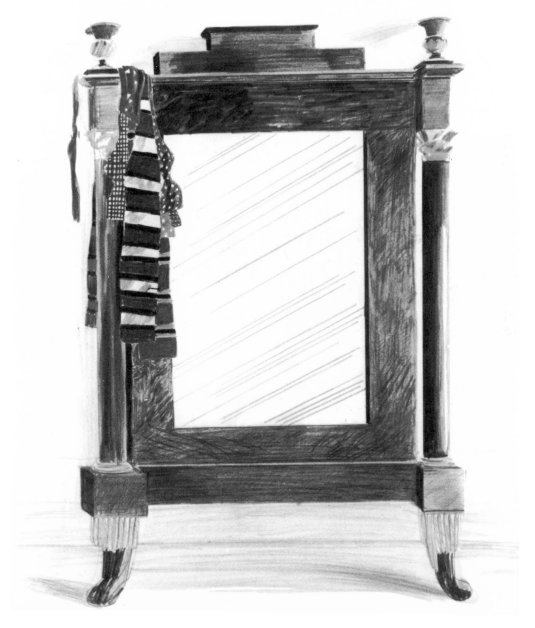

Mirror, Casa Santini, 1973

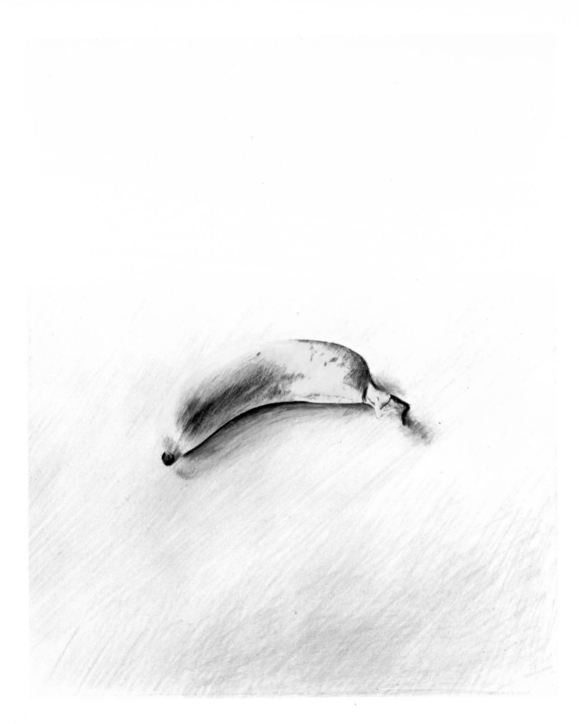

Banana, 1970

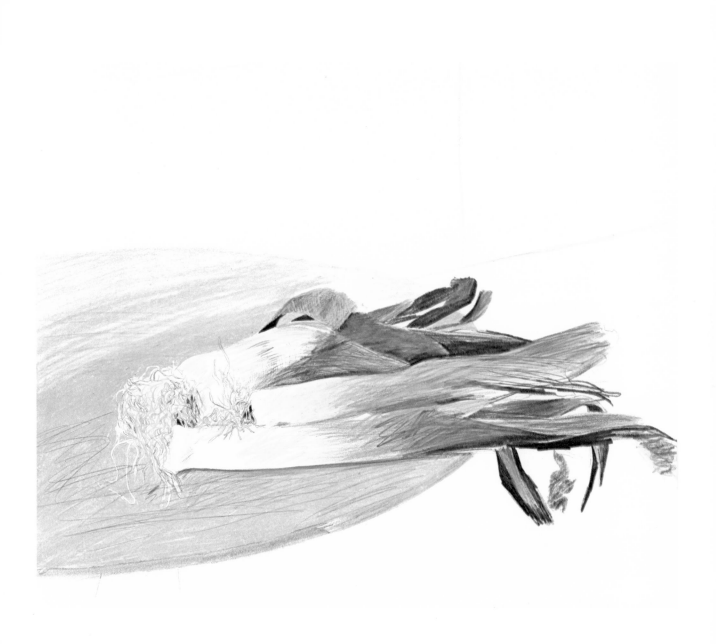

Leeks, 1970

Park Hotel, Munich, 1972

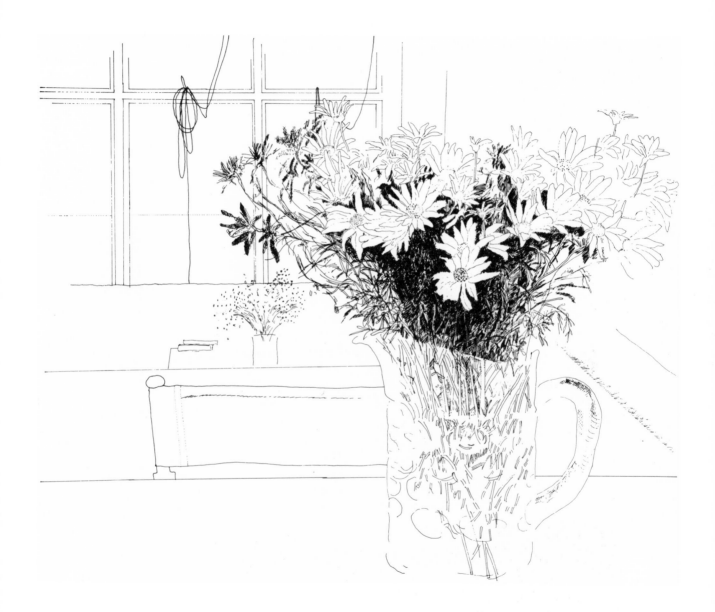

Flower Still Life, 1975

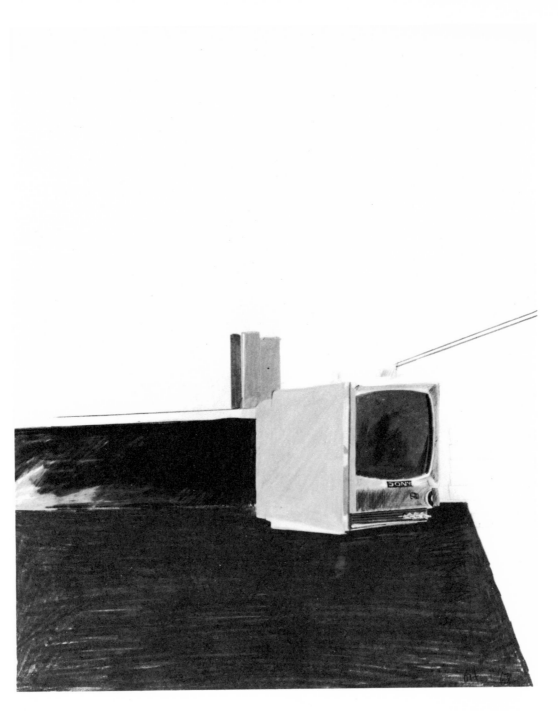

Sony TV, 1968

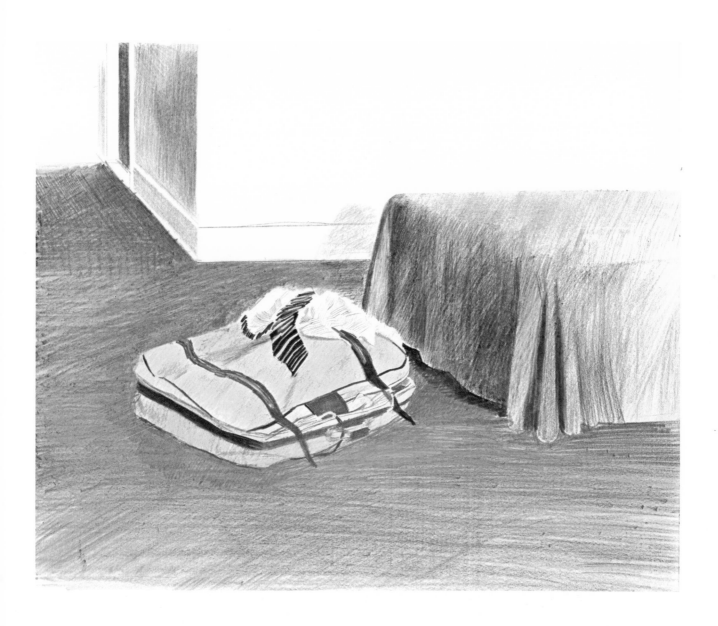

Hotel Room, Hot Springs, Arkansas, 1976

The Princess in Her Tower, 1969. *Etching and aquatint*, 18 x 13 inches (46 x 33 cm)
Rapunzel Growing in the Garden, 1969. *Etching and aquatint*, 18 x 13 inches (46 x 33 cm)
Old Rinkrank Threatens the Princess, 1969. *Etching and aquatint*, 9 x 11 inches (24 x 28 cm)
The Sexton Disguised as a Ghost, 1969. *Etching and aquatint*, 13 x 18 inches (33 x 46 cm)
A Black Cat Leaping, 1969. *Etching and aquatint*, 9 x 11 inches (24 x 28 cm)
The Boy Hidden in a Fish, 1969. *Etching and aquatint*, 9 x 11 inches (24 x 28 cm)
A Room Full of Straw, 1969. *Etching and aquatint*, 10 x 8 inches (26 x 23 cm)
The Boy Hidden in an Egg, 1969. *Etching and aquatint*, 8 x 7 inches (21 x 18 cm)
The Pot Boiling, 1969. *Etching and aquatint*, 7 x 8 inches (18 x 21 cm)
Riding Around on a Cooking Spoon, 1969. *Etching and aquatint*, 7 x 10 inches (17 x 26 cm)
The Rose and the Rose Stalk, 1969. *Etching*, 11 x 5 inches (29 x 13 cm)
The Lake, 1969. *Etching and aquatint*, 18 x 13 inches (46 x 33 cm)
Cold Water About to Hit the Prince, 1969. *Etching and aquatint*, 16 x 11 inches (40 x 28 cm)

1 'They're more complex than my previous etchings. First of all, instead of using aquatints to get tone I decided on a method of cross-hatching, which I used throughout. And then I found that you can get very rich black by cross-hatching, then etching, then putting wax on again, and then drawing another cross-hatch on top on another, on another; the ink gets very thick.'

2 'My choice of stories was occasionally influenced by how I might illustrate them. For example, *Old Rinkrank* was included because the story begins with the sentence, "A King built a glass mountain." I loved the idea of finding how you draw a glass mountain. There are all kinds of references. For example, the room full of straw is a reference to Magritte – those paintings where he's playing with scale.'

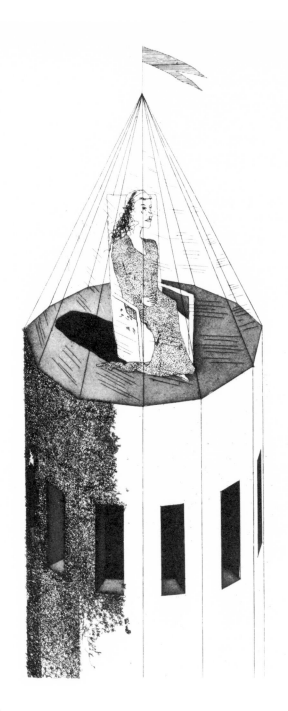

The Princess in Her Tower, 1969

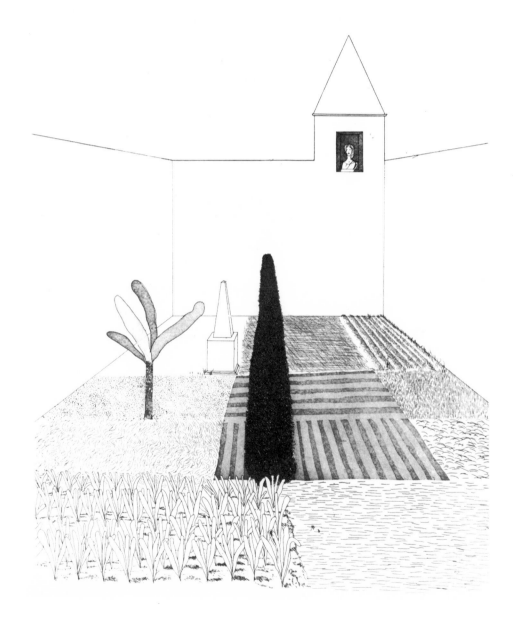

Rapunzel Growing in the Garden, 1969

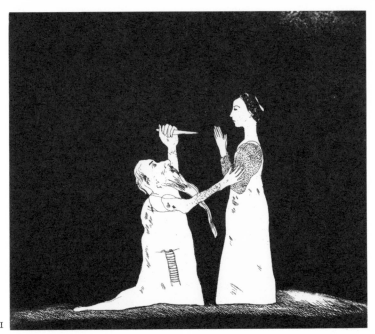

1

2

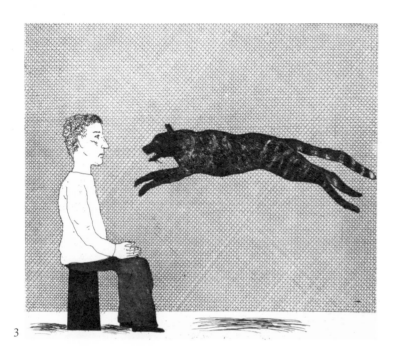

3

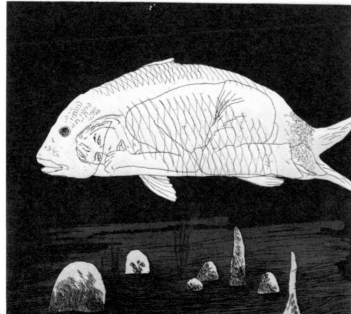

4

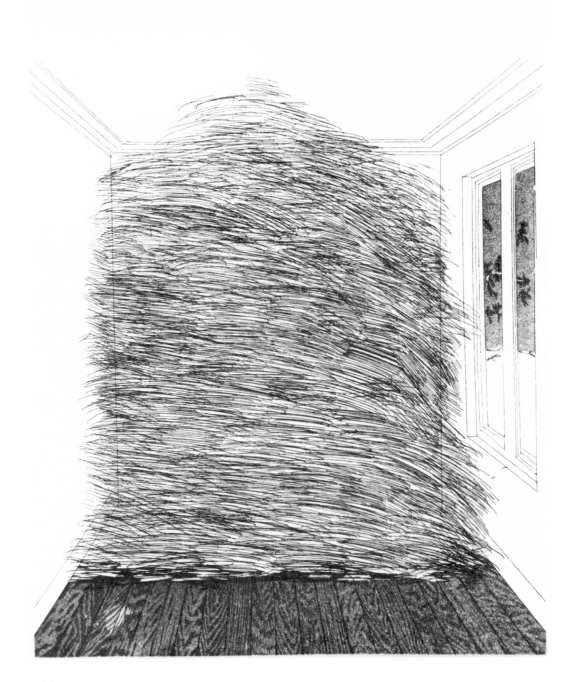

A Room Full of Straw, 1969

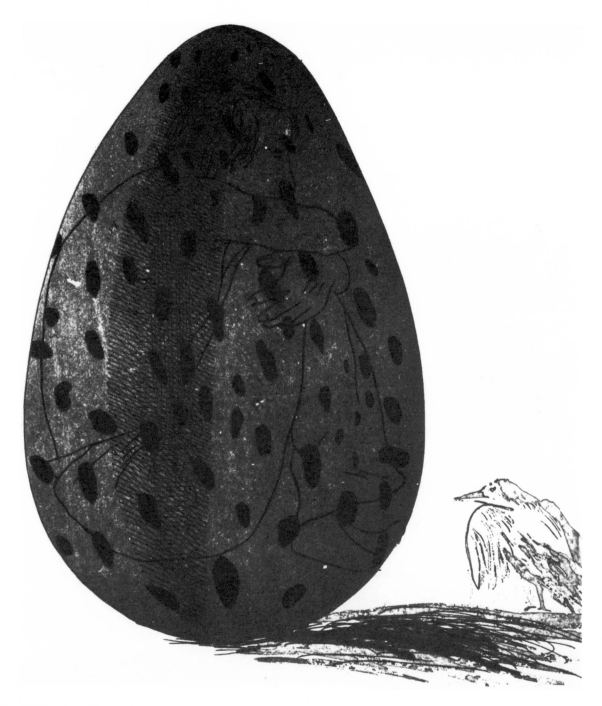

The Boy Hidden in an Egg, 1969

I

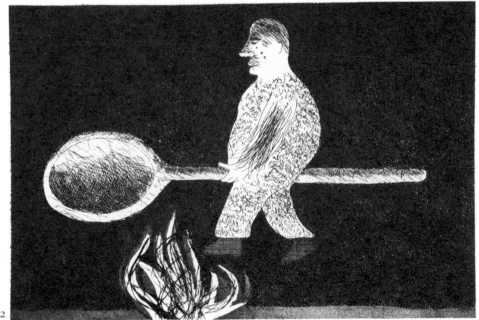

2

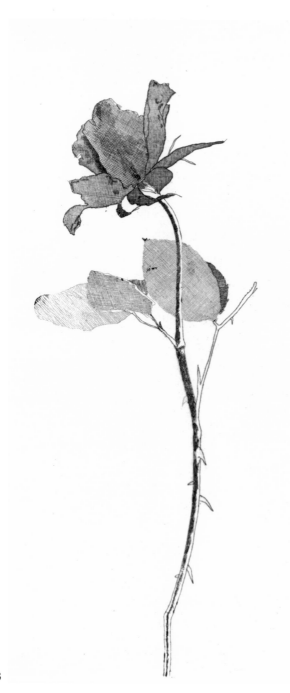

3

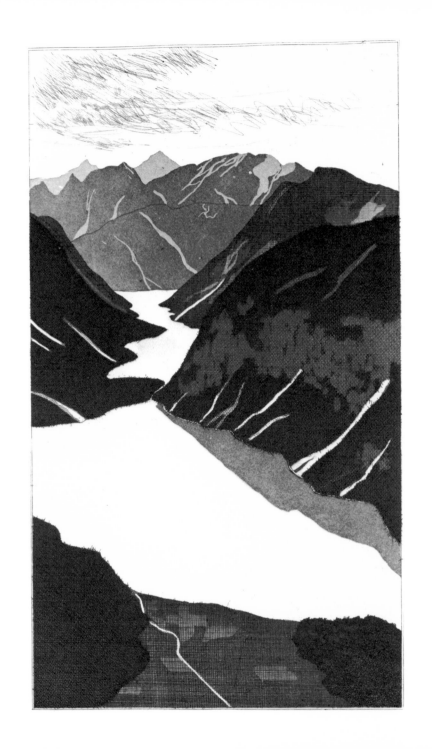

The Lake, 1969

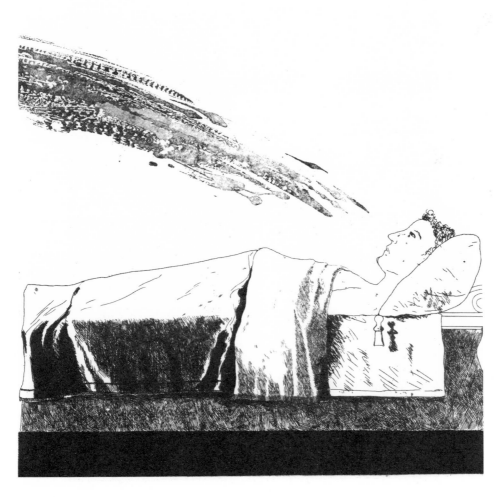

Cold Water About to Hit the Prince, 1969

Henry, Seventh Avenue, 1972. *Crayon*, 17 x 14 inches (43 x 35.5 cm)
Henry in Candlelight, 1975. *Crayon*, 17 x 14 inches (43 x 35.5 cm)
Henry 1973, 1973. *Lithograph*, 16 x 12 inches (40 x 30 cm)
Henry 1976, 1976. *Lithograph*, 14 x 12 inches (36 x 30 cm)
Henry 1972, 1972. *Crayon*, 17 x 14 inches (43 x 35.5 cm)
Henry, Grand Hotel, Calvi, 1972. *Crayon*, 17 x 14 inches (43 x 35.5 cm)
Henry at Table, 1976. *Lithograph*, 29.75 x 41.5 inches (75 x 112 cm)
Henry in Italy, 1973. *Ink*, 14 x 17 inches (35.5 x 43 cm)
Henry in Deckchair, 1973. *Crayon*, 17 x 14 inches (43 x 35.5 cm)
Sant' Andrea in Caprile, 1973. *Ink*, 17 x 14 inches (43 x 35.5 cm)

1 'I was polite and said I don't do commissioned portraits and I might perhaps do a drawing. But later on a few people said Why don't you do it? First of all, if you've never done a commissioned portrait, how can you say you can't do them, or shouldn't do them? At least you should do one. Now I've done one, I would never do another, but at the time I thought, it is an interesting idea to do somebody that asks me, rather than my choosing him. In the past I'd chosen to do people because I know something about the relationship.'

2 'I decide to do them myself, you see, like Christopher and Don – Christopher didn't ask me to paint him, I decided I'd like to do it and consequently they're done mostly of friends.'

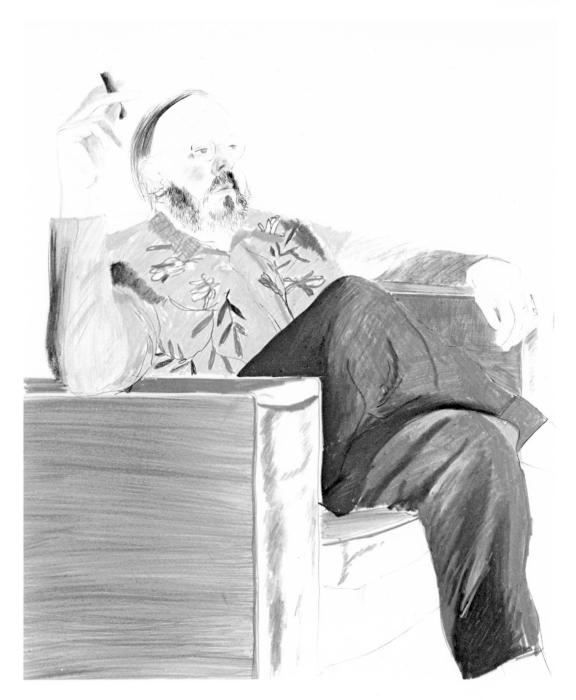

Henry, Seventh Avenue, 1972

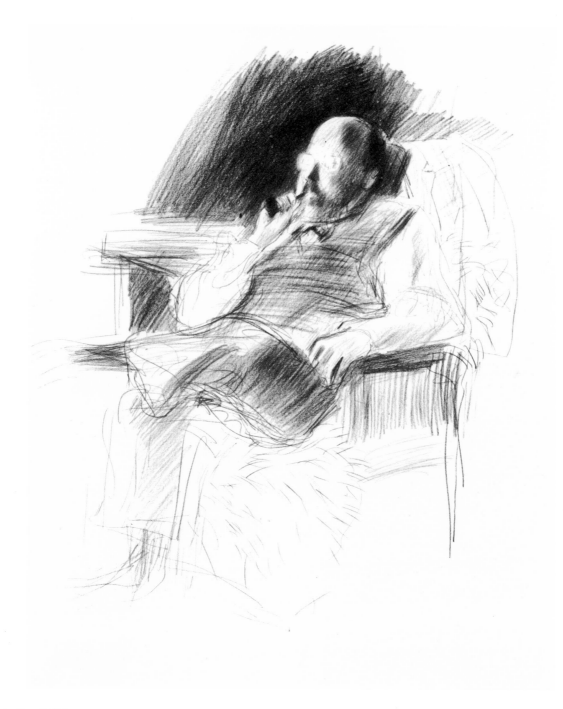

Henry in Candlelight, 1975

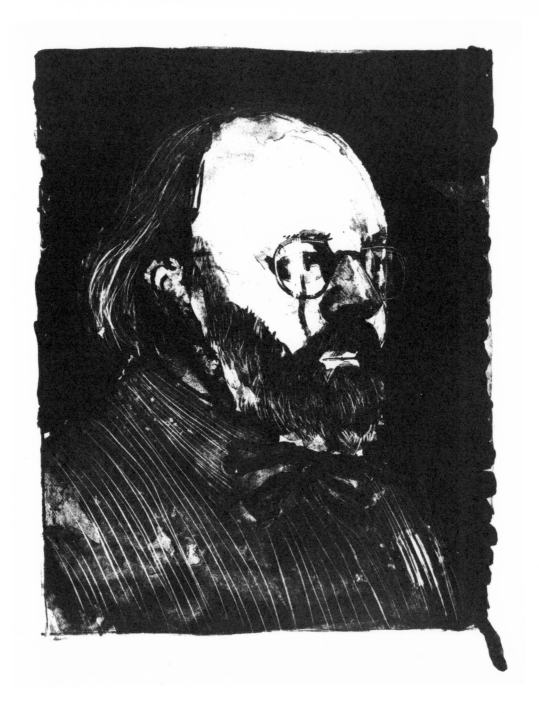

Henry 1973, 1973

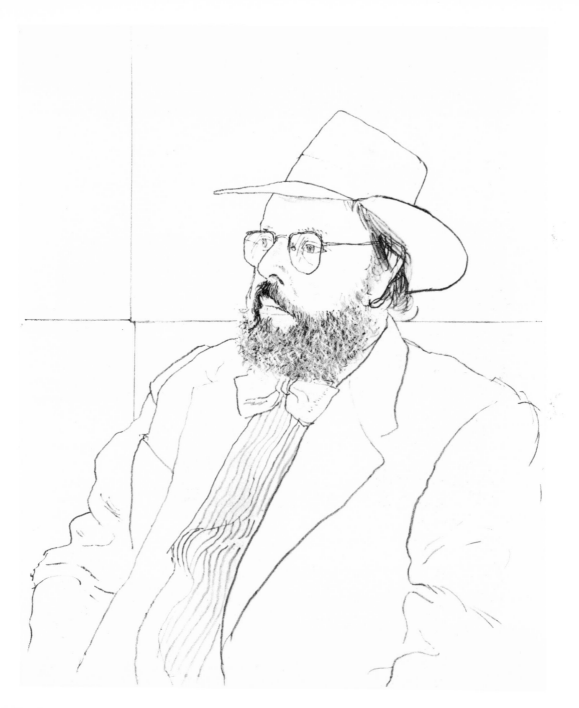

Henry 1976, 1976

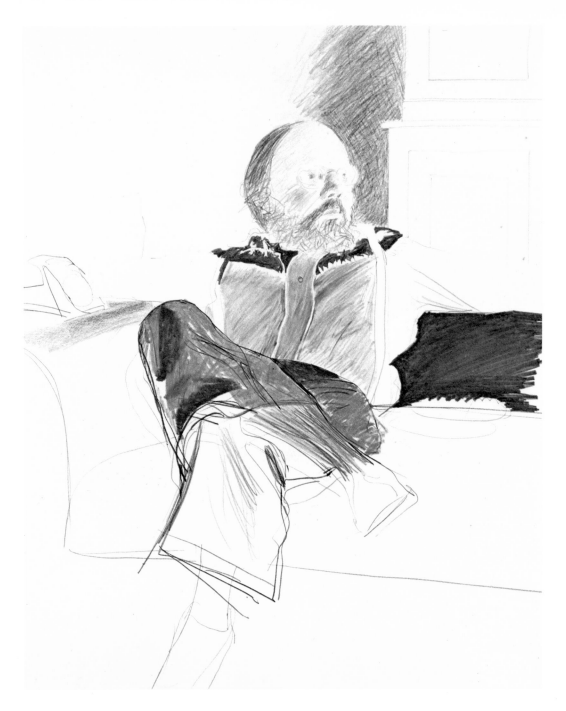

Henry 1972, 1972

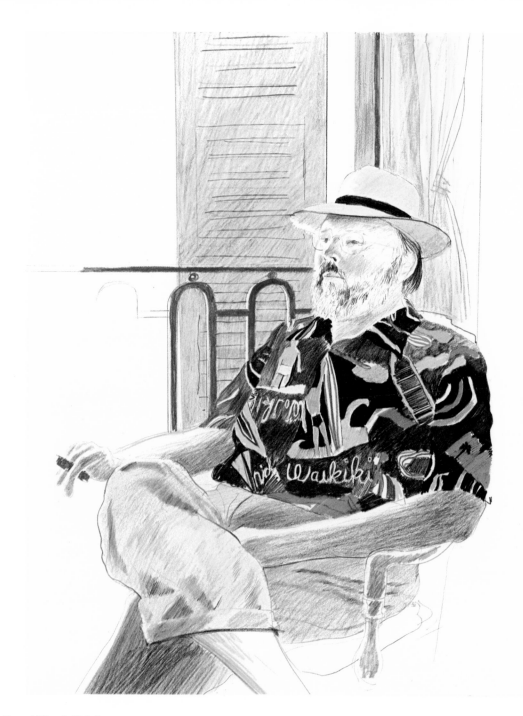

Henry, Grand Hotel, Calvi, 1972

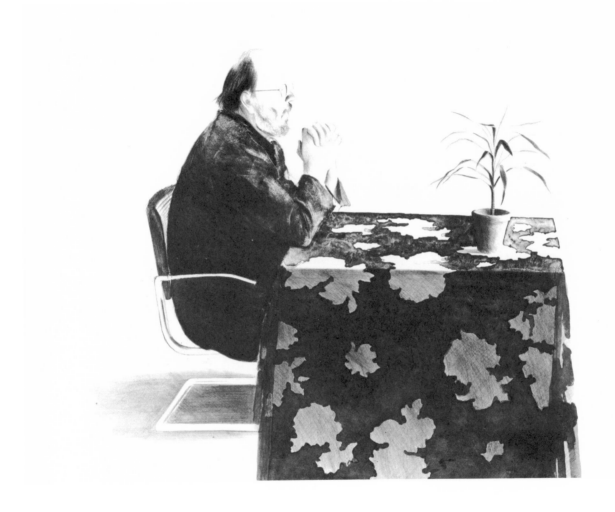

Henry at Table, 1976

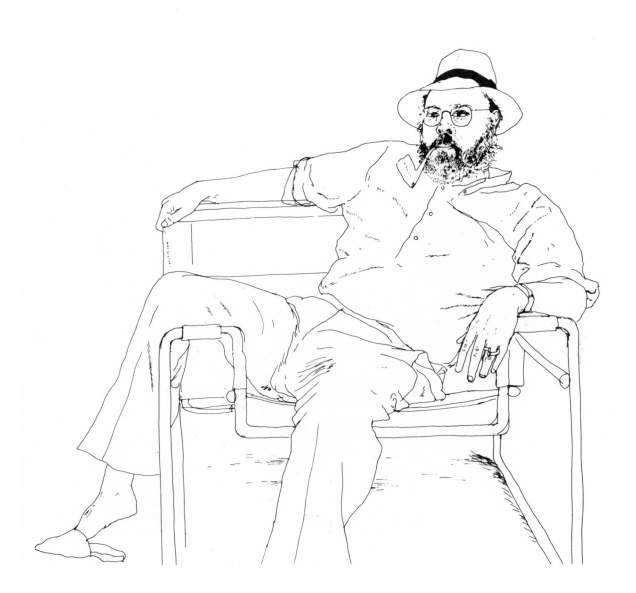

Henry in Italy, 1973

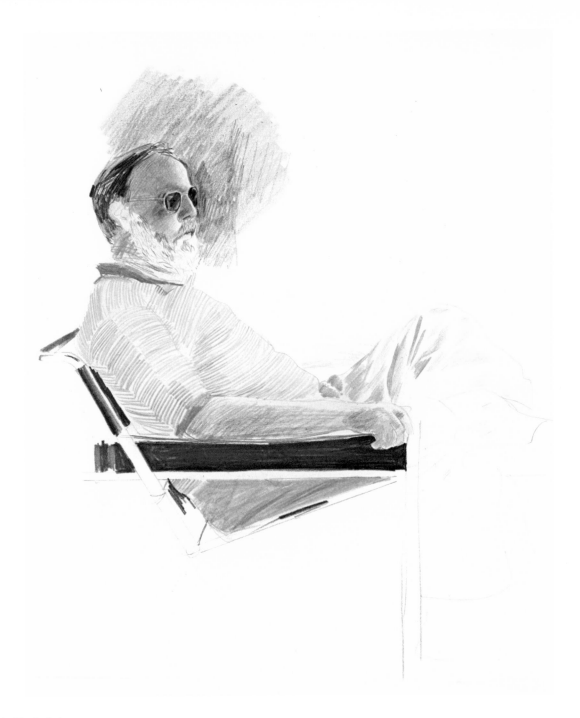

Henry in Deckchair, 1973

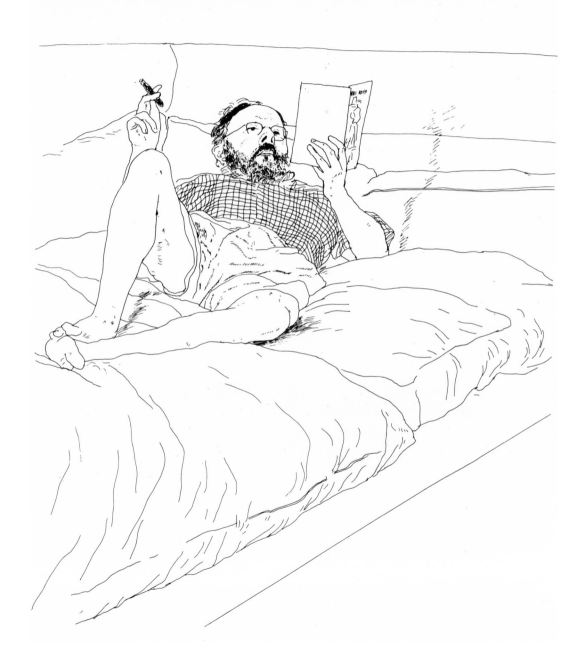

Sant' Andrea in Caprile, 1973

The Sphinx, 1963. *Pencil and crayon*, 12.75 x 10.5 inches (32.5 x 26.5 cm)
Rehotpe and his Wife Negret sat in a Glass Case in the Cairo Museum, 1963. *Pencil and crayon*, 20 x 12.5 inches (51 x 32 cm)
View from the Nile Hilton, 1963. *Pencil and crayon*, 12.25 x 9.75 inches (31 x 25 cm)
Cecil Hotel, Alexandria, I, 1963. *Crayon*, 12.5 x 10 inches (31.7 x 25.5 cm)
Shell Garage, 1963. *Crayon*, 11 x 15 inches (28 x 38 cm)
Alexandria 1963, 1963. *Crayon*, 14 x 17 inches (35.5 x 43 cm)
Mr Milo's House, Cairo, II, 1963. *Crayon*, 17 x 14 inches (43 x 35.5 cm)
Mr Milo's House, Cairo, I, 1963. *Crayon*, 17 x 14 inches (43 x 35.5 cm)
Shields, Cairo Museum, 1963. *Crayon*, 12.25 x 9.75 inches (31 x 25 cm)
The House of a Man who had made the Journey to Mecca, Luxor, 1963. *Crayon*, 12.25 x 9.75 inches (31 x 25 cm)

1 'I went to Egypt, in September 1963, for the *Sunday Times*. They knew I was interested in Egyptian art. So I went for three, four weeks, and I made a lot of drawings there, about forty drawings, I think. I drew everything. I went to Cairo, then Alexandria, and up to Luxor, where I spent about ten days.'

2 'I was interested in Egypt then for several reasons, in the style, and in Egyptian painting, which in a sense is not one of the really interesting methods of painting, by any means. Egypt is fascinating, but its painting is too rigid to be really intriguing. The only thing that interested me about it was that the rules were so rigid that there's no individualism in the paintings; whoever painted them, it didn't matter; they had to obey the rules and so it all looks the same. And that interested me, the annonymous aspect of the artist, but not the art.'

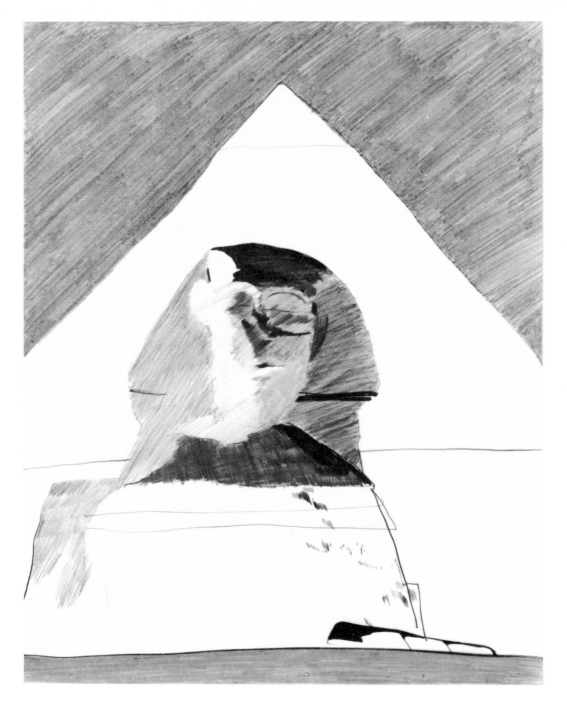

The Sphinx, 1963

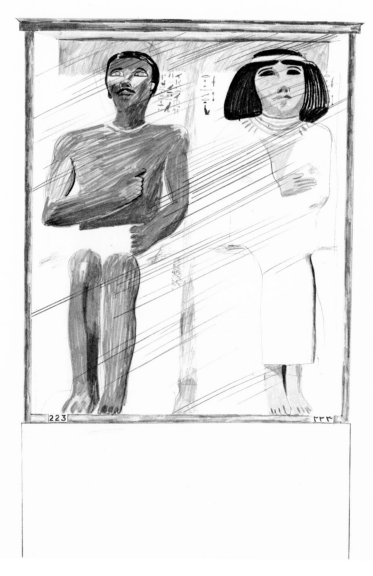

Rehotpe and his Wife Negret sat in a Glass Case in the Cairo Museum, 1963

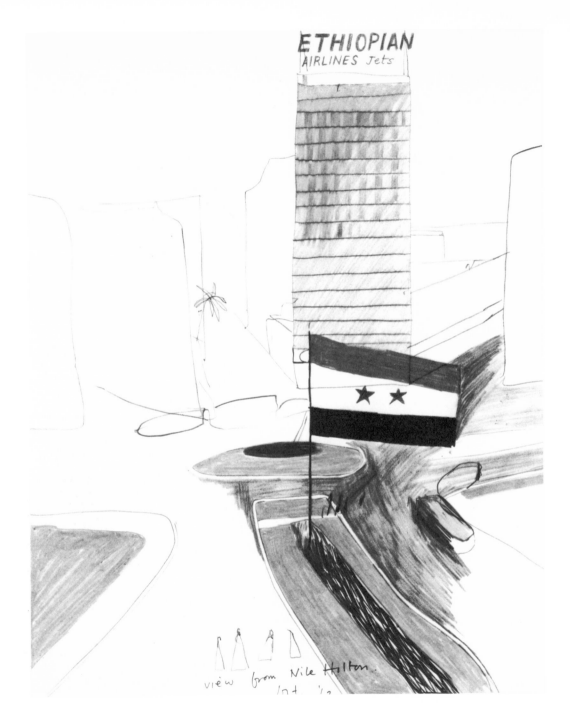

View from the Nile Hilton, 1963

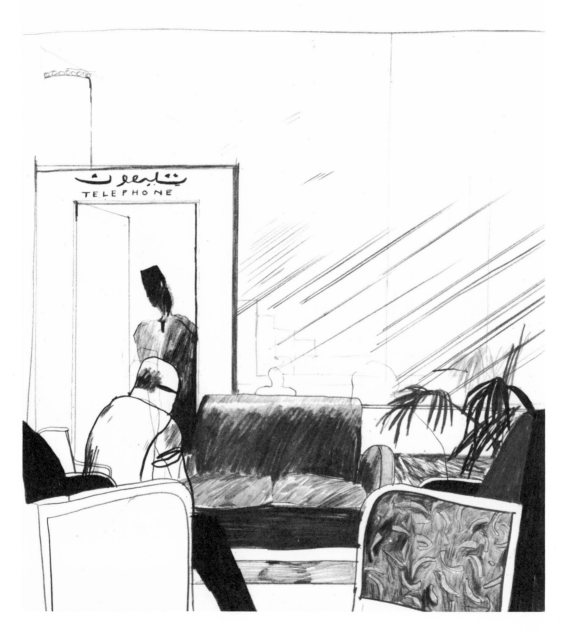

Cecil Hotel, Alexandria, I, 1963

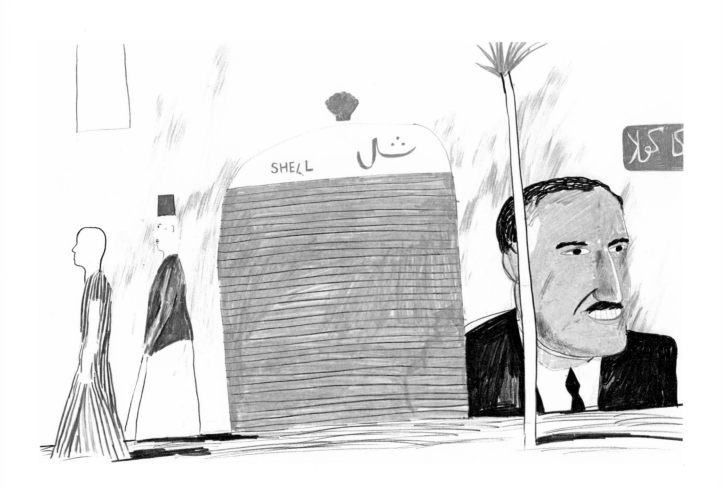

Shell Garage, 1963

Alexandria 1963, 1963

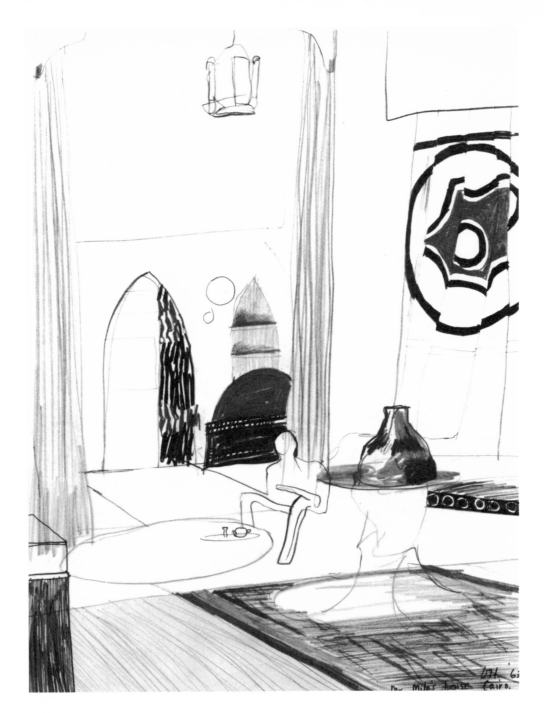

Mr Milo's House, Cairo, II, 1963

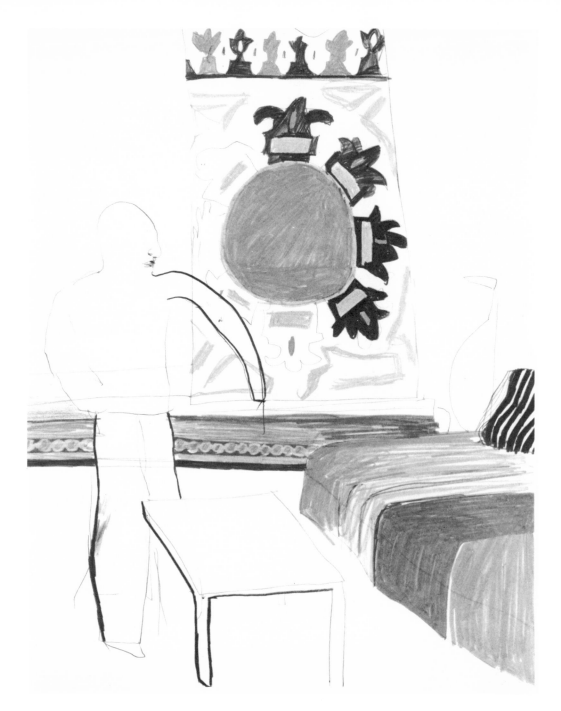

Mr Milo's House, Cairo, I, 1963

P27 W2 N

Shields, Cairo Museum, 1963

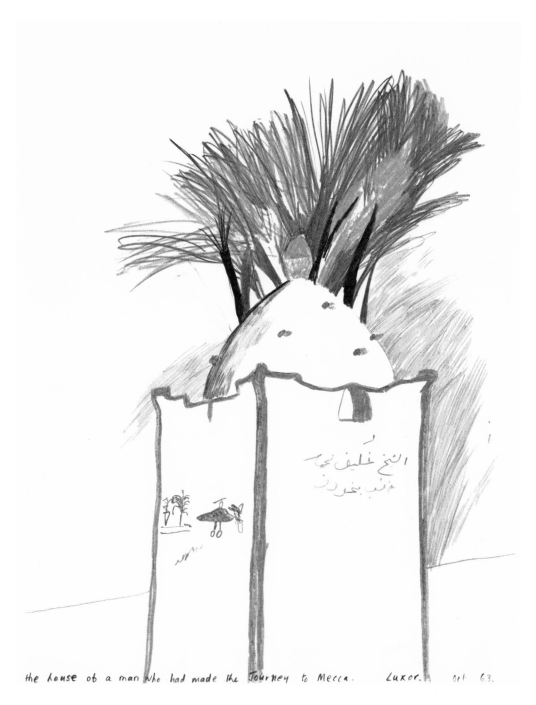

the house of a man who had made the Journey to Mecca. Luxor. Oct 63.

The House of a Man who had made the Journey to Mecca, Luxor, 1963

Index of quotations from the artist's statements

Page references are to: *David Hockney: Paintings, prints and drawings 1960-1970*, ed. Mark Glazebrook (catalogue for the exhibition at the Whitechapel Gallery, London, April 1970). *Cosmopolitan magazine*, London, November 1974.
David Hockney by David Hockney, ed. Nikos Stangos. Thames and Hudson, London, 1976. Harry N. Abrams, New York, 1976.

Biography

1937 Born in Bradford in the West Riding of Yorkshire and educated at Bradford Grammar School.

1953-57 Studied at Bradford College of Art.

1959-62 Studied at Royal College of Art, London. Met R. B. Kitaj and other artists.

1961 Won a prize for his print *Three Kings and a Queen* which enabled him to go to New York for the first time.
On returning to London painted *A Grand Procession of Dignitaries in the Semi-Egyptian Style*.
Awarded a prize in the John Moores Exhibition, Liverpool.
Started the series of etchings *A Rake's Progress*.

1962 Travelled to Berlin. Worked in London.

1963 Travelled to Egypt – Cairo, Alexandria and Luxor – at the invitation of the *Sunday Times*.
On his return painted *The Great Pyramid at Giza with Broken Head from Thebes* and *Play within a Play*.
First one man exhibition of paintings at the Kasmin Gallery in London.
Completed *A Rake's Progress* etchings in London published as a portfolio,
for which he won a prize at the Biennale des Jeunes Artistes in Paris.
Travelled to the United States.

1964 First one man exhibition in New York at the Alan Gallery. Works in the show were painted in California using acrylic paints.
Taught in Iowa for two months, toured United States by car and lived in Los Angeles.
Painted *Man Taking a Shower in Beverly Hills*.

1965 Worked in Los Angeles on a set of lithographs *A Hollywood Collection*
Taught at Colorado University.
Included in the exhibition *London : the New Scene* at the Walker Art Center, Minneapolis,
which toured Boston, Seattle, Vancouver and Toronto.
Exhibited at the Kasmin Gallery, London.
Painted in London *Different kinds of water pouring into a Swimming Pool, Santa Monica*.

1966 Went to Beirut in preparation for his work on the *Cavafy Etchings* in London.
Designed the sets and costumes for the Royal Court, London production of Alfred Jarry's *Ubu Roi*.
Taught at UCLA
Exhibition of drawings at the Stedelijk Museum, Amsterdam; and of paintings at the Palais des Beaux Arts, Brussels.
Taught at the University of California, Berkeley, where he painted *A Bigger Splash*.

1967 Bought a 35 mm camera and started to catalogue his photographs in albums.
Awarded first prize at the John Moores Exhibition.
Exhibited at the Alan Gallery, New York.

1968 Exhibited at the Kasmin Gallery, London.
Documenta IV exhibition in Kassel consolidated his reputation in Europe.
Double portrait *Christopher Isherwood and Don Bachardy* painted in Los Angeles.

1969 Travelled in the United States and Europe.
Painted in London *Henry Geldzahler and Christopher Scott*.
Completed *Six Fairy Tales from the Brothers Grimm* published as a book.
Exhibition at the Emmerich Gallery, New York.

1970 Painted *Le Parc des Sources, Vichy* in London.

Retrospective exhibition of ten years' work at the Whitechapel Gallery, London; travelled to Hanover, Rotterdam and Belgrade.

Jack Hazan started filming *A Bigger Splash*.

1971-72 Worked on *Portrait of an Artist sur la Terasse* in London.

Travelled to California, Honolulu and Japan.

Exhibition at the Emmerich Gallery, New York.

1973 Worked on extensive group of lithographs in Los Angeles at Gemini.

Lived in Paris and worked on etchings with Aldo Crommelynck.

1974 Started working in oil paints again. Painted *Contrejour in the French Style*.

Retrospective exhibition at the Musée des Arts Décoratifs in Paris.

Designed sets and costumes in Los Angeles for Glyndebourne production of Stravinsky's *Rake's Progress*.

1975 Lived in Paris.

Rake's Progress staged at Glyndebourne.

Exhibited at the Galerie Claude Bernard, Paris

1976 Selected photographs for *Twenty Photographic Pictures* published as a portfolio.

Exhibition of drawings, prints and photographs at Wilder Gallery, Los Angeles.

Worked on *Portraits of Friends* lithographs at Gemini.

Visited Australia.

Started work on *The Blue Guitar* etchings in London

1977 Travelled to India.

Completed painting second version of *Portrait of my Parents*.

The Blue Guitar as portfolio and book

Retrospective exhibition of prints and drawings exhibited in Madrid, Munich, Lisbon and Tehran.

Worked on sets and costumes in New York for the Glyndebourne production of Mozart's *The Magic Flute*, for staging May 1978.

Completed *Looking at Pictures on a Screen*.

Exhibited at the Emmerich Gallery, New York.

Selected bibliography

Books and catalogues

David Hockney: Paintings, prints and drawings 1960-1970
 ed. Mark Glazebrook (catalogue for the exhibition at the Whitechapel Gallery, London, April 1970).
David Hockney: Paintings and Drawings.
 Illustrated catalogue for the exhibition at the Musée des Arts Décoratifs, Palais du Louvre, Paris, 11 October – 9 December 1974.
 The British Council, London, 1974.
David Hockney by David Hockney ed. Nikos Stangos. Thames and Hudson, London, 1976. Harry N. Abrams, New York, 1976.

Articles

Ark 32, Journal of the Royal College of Art, London, Summer 1962. Article by Richard Smith.

The London Magazine Vol. 3. No. 1, April 1963. Guy Brett: "David Hockney: A Note in Progress."
The Studio Vol. 166. No. 848, December 1963, pages 252-253. G.S. Whittet: "David Hockney: His Life and Good Times."
The Times (London) 17 December 1963. Bryan Robertson: "The New Generation: Opportunities and Pitfalls."

Arts Magazine Vol. 38. No. 9, May-June 1964, pages 94-101.
 Gene Baro: "The British Scene," article on David Hockney and R.B. Kitaj.
Cambridge Opinion No. 37, 1964, pages 57-58. "Paintings with Two Figures."
The New Generation: catalogue for an exhibition at the Whitechapel Gallery, London, 1964. Article by David Thompson.

The London Magazine Vol. 5. No. 10, January 1966, pages 68-73. Robert Hughes: "Blake and Hockney."
The Times (London) 3 May 1966. Edward Lucie-Smith: "David Hockney."
Studio International Vol. 171, May 1966. Gene Baro: "David Hockney's Drawings."
Art and Artists May 1966. Gene Baro: "Hockney's *Ubu.*"

Studio International Vol. 175. No. 896, January 1968, pages 36-38.
 Charles Harrison: "David Hockney at Kasmin in London" Commentary.

Art News Vol. 68. No. 3, May 1969. David Shapiro: "David Hockney paints a Portrait."
Arts Magazine Summer 1969. Frank Bowling: "A Shift in Perspective."
Vogue (London) December 1969. Cecil Beaton: "Seeing Eye to Eye."
Financial Times (London) 18 December 1969. Paul Overy: "Hockney's Grimms Etchings."
The Times (London) 20 December 1969. Guy Brett: "David Hockney."
Image as Language: Aspects of British Art 1950-1968 a book by Christopher Finch. Penguin Books, London, 1969, pages 111-115.

Arts Review (London) 28 March 1970. Pat Gilmour: "David Hockney."
The Observer 28 March 1970. Nigel Gosling: "A Decade of Hockney."
The Observer (Color Supplement) 28 March 1970. "No Dumb Blond."
Art and Artists (London) April 1970. John and Christopher Battye: "Interviews with David Hockney."
Nova (London) April 1970. Edward Lucie-Smith: "The Real David Hockney."
The Times (London) 2 April 1970. Guy Brett: "Hockney's Poetry and Wit."
The Sunday Times 5 April 1970. John Russell: "Hockney's Progress."
The Spectator 11 April 1970. Paul Grinke: "Love and Friendship."
The Evening Standard (London) 14 April 1970. Richard Cork: "Hockney, Sixties Swinger on the Edge of Greatness."
The Guardian 25 April 1970. Norbert Lynton: "David Hockney."
New York Times 26 April 1970. Norbert Lynton: "Hockney: How His Style Changes."
Studio International May 1970. "Hockney's Retrospective."
The New Statesman 30 July 1970. Robert Melville: "Not Quite Flat."

Los Angeles Times 6 June 1971. William Wilson: "Somebody over there likes us."
Daily Telegraph Magazine (London) 10 December 1971. V.S.Naipaul: "An Escape from the Puritan Ethic."

The Times (London) 4 April 1972. Guy Brett: "Game of Style."
Time Magazine 29 May 1972. Robert Hughes: "Bland and Maniacal."

The Guardian (London) Arts Guardian 15 May 1974. Michael McNay: "Pop goes the Easel" (on film "The Bigger Splash").
The Financial Times (London) 20 July 1974. William Packer: "David Hockney."
The Times (London) 17 October 1974. Michael Ratcliffe: "Confrontation at the Louvre."
Le Monde 31 October 1974. Jaques Michel: "Peindre pour dépeindre. Nouvelle situation de David Hockney".
 (On film "The Bigger Splash").
Arts Magazine November 1974, pages 66-67. John Loring: "David Hockney Drawings."
Arts Review (London) 1 November 1974. Ray Miles: "Hockney in Paris."
International Herald and Tribune 2 November 1974. Michael Gibson: "Hockney – An Ironic Tourist who takes a Detached View."
The Guardian (London) 5 November 1974. Alan Stevenson: "Paris."
Frankfurter Allgemeine Zeitung 3 December 1974. "Der Mythes von Wasser und Traum."
The Evening Standard (London) 12 December 1974. Alexander Walker: "A Small Ripple in Hockney Land."

The Observer Color Supplement, February 1975. John Heilpern: "In the Picture with David Hockney."
Hampstead and Highgate Express 21 March 1975. Adrian Turner: "Hockney Marshes . . ."
Radio Times 15 May 1975. David Pryce-Jones: "Making a Splash."
The Times (London) 19 May 1975. David Robinson: "David Hockney in the buff."
The Listener 22 May 1975. Conversation with Melvyn Bragg from Omnibus (B.B.C. Television).
Newsweek (New York) 26 May 1975. Carter S.Wiseman with Jane Friedman in Paris: "Heights of Hockney."

Encounter (London) June 1975. John Weightman: "Narcissi round the Pool."
The Guardian (London) 20 June 1975. Michael McNay: "Glyndebourne à la mode."
The Financial Times 23 June 1975. Ronald Crichton: *The Rake's Progress.*
The Times (London) 23 June 1975. William Mann: "More Hockney than Hogarth."
The Observer (London) 29 June 1975. Peter Heyworth: "The Rake's Triumph."
DU (Zurich) July 1975. Sarah Fox-Pitt: "David Hockney und *The Rake's Progress.*"

Street Life 24 January – 6 February 1976. Simon Stables: "Hockney on Hockney."
New West Magazine (Los Angeles) 26 April 1976. Anthony Haden Guest: "A Bright and Lucid Land."
The Times (London) 14 August 1976. Roger Berthoud: "Grand Young Man."
The Guardian (London) 21 October 1976. Melvyn Bragg: "Hockney's Progress."
The New Statesman (London) 22 October 1976. Robert Melville: "Naked Youth."
The Sunday Times (London) 24 October 1976. Albert Hunt: "The Innocent Eye."
The Oxford Mail 28 October 1976. John Rothenstein: "The Riveting David Hockney."
The Sunday Telegraph (London) 31 October 1976. Michael Shepherd: "Paint and People."
The Spectator 6 November 1976. John McEwan: "Gold Dust."
The Times Literary Supplement 3 December 1976. Nicholas Phillipson: "Self-Portrait with Allegories."

Books and Bookmen January 1977. Douglas Cooper: "New Bearings in British Art."
Stern April 1977. "Licht-Spiele in Swimming Pools."
Sunday Times Magazine 1 May 1977. Barry Fantoni: "Gold Fingers."
New York Times 20 May 1977. Grace Glueck: "Art People."
The Times Literary Supplement 5 August 1977. Tim Hilton: "South Bank-ruptcy."
Horizon November 1977. Nigel Gosling: "Things exactly as they are."
New York Times 4 November 1977. Hilton Kramer: "Art: The Fun of David Hockney."
Newsweek 14 November 1977. Mark Stevens: "A Stylish Realist."
Art Monthly (London) No. 12, November 1977. "An Interview with David Hockney. Part I."
 Part II to appear in the December/January issue.
The New Yorker Profile by Anthony Bailey (in preparation).

Checklist of Works in the Exhibition

Drawings

1 Berliner and Bavarian, 1962. *Crayon*, 20 x 23.75 inches. Collection Kasmin Ltd.
2 Renaissance Head, 1962. *Pencil and crayon*, 16 x 11 inches. Collection Ibart Ltd.
3 Colonial Governor, 1962. *Crayon*, 13 x 10 inches. Private Collection. (Illustrated)
4 Viareggio 1962. *Crayon,* 19 x 13.25 inches. Private Collection.
5 Cecil Hotel, Alexandria I, 1963. *Crayon*, 12.5 x 10 inches.
 Collection Kunstmuseum Basel, Kupferstichkabinett, K. A. Burckhardt–Koechlin–Fonds. (Illustrated)
6 The House of a Man Who Had Made the Journey to Mecca, Luxor, 1963. *Crayon*, 12.25 x 9.75 inches. Private Collection. (Illustrated)
7 Shell Garage, 1963. *Crayon*, 11 x 15 inches. Private Collection. (Illustrated)
8 Evil Man, 1963. *Crayon*, 20 x 12.5 inches. Private Collection. (Illustrated)
9 Figure Composed of Two Red Spheres and a Rectangle, 1963. *Pencil and crayon*, 12.25 x 10 inches. Private Collection. (Illustrated)
10 Skittle Stood in Front of a Picture of a Man Jumping, 1963. *Pencil and crayon*, 20 x 23.5 inches. Private Collection. (Illustrated)
11 Coloured Curtain Study, 1963. *Pencil and crayon*, 16 x 12.5 inches. Collection Erich Sommer. (Illustrated)
12 Cubistic Woman, 1963. *Pencil and crayon*, 12.25 x 9.75 inches. Collection Mrs. Sidney Corob. (Illustrated)
13 Shower Study, 1963. *Chalk and pencil*, 19.75 x 12 inches. Collection The Marquis of Dufferin and Ava. (Illustrated)
14 Mr. Milo's House, Cairo I, 1963. *Crayon*, 12.5 x 10 inches. Private Collection. (Illustrated)
15 Mr. Milo's House, Cairo II, 1963. *Crayon*, 12.5 x 10 inches. Private Collection. (Illustrated)
16 American Boys Showering, 1964. *Pencil and crayon*, 19.75 x 12.5 inches.
 Collection Kunstmuseum Basel, Kupferstichkabinett, K. A. Burckhardt–Koechlin–Fonds. (Illustrated)
17 Pershing Square Study I, 1964. *Pencil*, 10.75 x 13.75 inches. Private Collection.
18 American Cubist Boy, 1964. *Pencil and crayon*, 11 x 14 inches. Collection Vivienne Halban. (Illustrated)
19 Grass and Clouds, 1964. *Crayon*, 19 x 12 inches. Private Collection. (Illustrated)
20 Hollywood Pool and Palm Tree, 1965. *Crayon*, 12.5 x 17 inches. Private Collection. (Illustrated)
21 Bob Aboard the "France", 1965. *Pencil and crayon*, 19 x 24 inches. Private Collection. (Illustrated)
22 Cubistic Tree, 1965. *Crayon*, 14 x 17 inches. Private Collection.
23 Striped Water, 1965. *Crayon*, 13.75 x 16.5 inches. Collection Petersburg Press. (Illustrated)
24 Swimming Pool and Garden, Beverly Hills, 1965. *Pencil and crayon*, 19 x 24 inches. Collection Kasmin Ltd. (Illustrated)
25 Peter, Dream Inn, Santa Cruz, 1966. *Pencil and crayon*, 14 x 17 inches. Collection The Artist.
26 Mountain Landscape, Lebanon, 1966. *Crayon*, 15.75 x 19.5 inches. Private Collection. (Illustrated)
27 Police Building, Beirut, 1966. *Ink*, 17 x 14 inches. Private Collection.
28 1059 Baboa Boulevard, 1967. *Crayon*, 14 x 17 inches. Collection Kasmin Ltd. (Illustrated)
29 Nice, 1968. *Crayon*, 14 x 17 inches. Private Collection. (Illustrated)
30 Sony T.V., 1968. *Crayon*, 17 x 14 inches. Collection Kasmin Ltd. (Illustrated)
31 Celia, Paris, 1969. *Ink*, 17 x 14 inches. Collection Kasmin Ltd. (Illustrated)
32 Peter Langan, 1969. *Ink*, 17 x 14 inches. Collection Peter Langan.
33 Henry, Le Nid du Duc, 1969. *Ink*, 17 x 14 inches. Collection Kasmin Ltd.
34 Corbusier Chair and Rug, 1969. *Crayon*, 17 x 14 inches. Collection The Artist. (Illustrated)

35 Carennac, 1970. *Ink*, 14 x 17 inches. Collection Kasmin Ltd. (Illustrated)

36 Banana, 1970. *Crayon*, 17 x 14 inches. Collection The Marquis of Dufferin and Ava. (Illustrated)

37 Leeks, 1970. *Crayon*, 14 x 17 inches. Collection Kasmin Ltd. (Illustrated)

38 Ossie Wearing a Fairisle Sweater, 1970. *Crayon*, 17 x 14 inches. Collection The Marquis of Dufferin and Ava. (Illustrated)

39 Ossie, 1970. *Ink*, 17 x 14 inches. Collection Kasmin Ltd. (Illustrated)

40 Window, Grand Hotel, Vittel, 1970. *Crayon*, 17 x 14 inches. Private Collection. (Illustrated)

41 Tulips, 1971. *Ink*, 17 x 14 inches. Collection Kasmin Ltd.

42 Celia, Carennac, 1971. *Crayon*, 17 x 14 inches. Collection The Artist. (Illustrated)

43 Balcony, Mamounia Hotel, Marrakesh, 1971. *Crayon*, 14 x 17 inches. Collection Kasmin Ltd. (Illustrated)

44 Radishes, 1971. *Crayon*, 14 x 17 inches. Collection Kasmin Ltd.

45 Oriental Hotel, Bangkok, 1971. *Crayon*, 17 x 14 inches. Collection Mr. and Mrs. Giuseppe Eskenazi. (Illustrated)

46 Royal Hawaiian Hotel, Waikiki Beach, Honolulu, 1971. *Crayon*, 14 x 17 inches. Collection Kasmin Ltd. (Illustrated)

47 Kyoto, 1971. *Crayon*, 14 x 17 inches. Collection Kasmin Ltd. (Illustrated)

48 Mark, Suginoi Hotel, Beppu, 1971. *Crayon*, 17 x 14 inches. Collection Kasmin Ltd. (Illustrated)

49 Suginoi Hotel, Beppu, 1971. *Crayon*, 14 x 17 inches. Collection The Marquis of Dufferin and Ava. (Illustrated)

50 Thierry, Grand Hotel, Calvi, 1972. *Ink*, 17 x 14 inches. Collection Kasmin Ltd.

51 Henry, Seventh Avenue, 1972. *Crayon*, 17 x 14 inches. Collection Henry Geldzahler. (Illustrated)

52 Celia, 1972, 1972. *Crayon*, 17 x 14 inches. Collection The Artist. (Illustrated)

53 Celia in a Black Dress, with White Flowers, 1972. *Crayon*, 17 x 14 inches. Collection Ibart Ltd. (Illustrated)

54 Celia Sleeping, 1972. *Ink*, 14 x 17 inches. Collection Jean Léger. (Illustrated)

55 The Artist's Mother, 1972. *Crayon*, 17 x 14 inches. Collection The Artist. (Illustrated)

56 My Father, 1972. *Ink*, 14 x 17 inches. Collection Ibart Ltd. (Illustrated)

57 Gary Farmer, 1972. *Crayon*, 17 x 14 inches. Collection Kasmin Ltd. (Illustrated)

58 Cushions, 1973. *Crayon*, 14 x 17 inches. Private Collection.

59 Chair, Italy, 1973. *Crayon*, 17 x 14 inches. Collection Kasmin Ltd.

60 Villa Reale, Marlia, 1973. *Crayon*, 14 x 17 inches. Collection Ibart Ltd. (Detail, illustrated)

61 Henry, Sant'Andrea in Caprile, 1973. *Ink*, 17 x 14 inches. Collection Kasmin Ltd. (Illustrated)

62 Mo, Paris, 1973. *Ink*, 17 x 14 inches. Collection Kasmin Ltd. (Illustrated)

63 Portrait of Jean Léger, 1973. *Pencil*, 24.5 x 19.5 inches. Collection Jean Léger.

64 Henry in a Deckchair, 1973. *Crayon*, 17 x 14 inches. Collection Kasmin Ltd. (Illustrated)

65 Celia in a Black Slip, Reclining, 1973. *Crayon*, 19.75 x 25.5 inches. Collection Ibart Ltd. (Illustrated)

66 Celia in a Black Slip, Curled Up, 1973. *Crayon*, 25 x 19.5 inches. Collection Ibart Ltd.

67 Celia in a Black Dress with Red Stockings, 1973. *Crayon*, 25.5 x 19.75 inches. Collection Ibart Ltd. (Illustrated)

68 My Mother, 1974. *Ink*, 17 x 14 inches. Collection Ibart Ltd.

69 Yves Marie, New York, 1974. *Crayon*, 17 x 14 inches. Collection Ibart Ltd.

70 Preliminary Sketch for "Louvre Window, Contrejour," 1974. *Crayon*, 14 x 17 inches. Collection Ibart Ltd.

71 Study for "Portrait of Nick Wilder and Gregory," 1974. *Crayon*, 19.75 x 25.5 inches. Collection Ibart Ltd.

72 Study for "My Parents and Myself," 1974. *Crayon*, 14 x 17 inches. Collection Ibart Ltd.

73 Don Cribb, Fire Island, 1975. *Crayon*, 17 x 14 inches. Collection Ibart Ltd.
74 Palm Reflected in Pool, Arizona, 1976. *Crayon*, 19.75 x 16 inches.
 Collection Mrs. Gardner Cowles and Charles Cowles. (Illustrated)
75 Still Life, Taj Hotel, Bombay, 1977. *Crayon*, 17 x 14 inches. Private Collection. (Illustrated)

Prints

76 Myself and My Heroes, 1961. *Etching and aquatint*, 10.25 x 19.75 inches.
77 Mirror, Mirror on the Wall, 1961. *Etching and aquatint*, 15.75 x 19.75 inches.
78 My Bonnie Lies Over the Ocean, 1962. *Etching, aquatint and collage*, 17.75 x 17.75 inches.
79 The Diploma, 1962. *Etching and aquatint*, 15.75 x 11 inches. (Illustrated)
80 The Marriage, 1962. *Etching and aquatint*, 11.75 x 15.75 inches. (Illustrated)
81 The Hypnotist, 1963. *Etching and aquatint*, 19.75 x 19.5 inches. (Illustrated)

A Rake's Progress, 1961–63, a portfolio of 16 etchings:
82 The Arrival. *Etching and aquatint*, 11.75 x 15.75 inches. (Illustrated)
83 Receiving the Inheritance. *Etching and aquatint*, 11.75 x 15.75 inches.
84 Meeting the Good People (Washington). *Etching and aquatint*, 11.75 x 15.75 inches. (Illustrated)
85 The Gospel Singing (Good People), Madison Square Garden. *Etching and aquatint*, 11.75 x 15.75 inches. (Illustrated)
86 The Start of a Spending Spree and the Door Opening for a Blond. *Etching and aquatint*, 11.75 x 15.75 inches. (Illustrated)
87 The 7 Stone Weakling. *Etching and aquatint*, 11.75 x 15.75 inches.
88 The Drinking Scene. *Etching and aquatint*, 11.75 x 15.75 inches. (Illustrated)
89 Marries an Old Maid. *Etching and aquatint*, 11.75 x 15.75 inches.
90 The Election Campaign (with Dark Message). *Etching and aquatint*, 11.75 x 15.75 inches. (Illustrated)
91 Viewing a Prison Scene. *Etching and aquatint*, 11.75 x 15.75 inches.
92 Death in Harlem. *Etching and aquatint*, 11.75 x 15.75 inches. (Illustrated)
93 The Wallet Begins to Empty. *Etching and aquatint*, 11.75 x 15.75 inches.
94 Disintegration. *Etching and aquatint*, 11.75 x 15.75 inches.
95 Cast Aside. *Etching and aquatint*, 11.75 x 15.75 inches.
96 Meeting the Other People. *Etching and aquatint*, 11.75 x 15.75 inches.
97 Bedlam. *Etching and aquatint*, 11.75 x 15.75 inches. (Illustrated)

98 Jungle Boy, 1964. *Etching and aquatint*, 15.75 x 19.25 inches. (Illustrated)
99 Pacific Mutual Life, 1964. *Lithograph*, 20 x 24.75 inches. (Illustrated)
100 Water Pouring into a Swimming Pool, Santa Monica, 1964. *Lithograph*, 20 x 26 inches.

A Hollywood Collection 1965, a portfolio of 6 lithographs:
101 Picture of a Still Life that has an Elaborate Silver Frame. *Lithograph*, 30.25 x 22 inches. (Illustrated)
102 Picture of a Landscape in an Elaborate Gold Frame. *Lithograph*, 30.25 x 22 inches. (Illustrated)
103 Picture of a Portrait in a Silver Frame. *Lithograph*, 30.25 x 22 inches. (Illustrated)
104 Picture of Melrose Avenue in an Ornate Gold Frame. *Lithograph*, 30.25 x 22 inches. (Illustrated)
105 Picture of a Simple Framed Traditional Nude Drawing. *Lithograph*, 30.25 x 22 inches. (Illustrated)
106 Picture of a Pointless Abstraction Framed under Glass. *Lithograph*, 30.25 x 22 inches. (Illustrated)

A Selection from: Illustrations for Fourteen Poems from C. P. Cavafy 1966, a portfolio of 13 etchings:
107 Portrait of Cavafy I. *Etching and aquatint*, 14 x 9 inches. (Illustrated)
108 Two Boys Aged 23 and 24. *Etching and aquatint*, 14 x 9 inches. (Illustrated)
109 He Enquired After the Quality. *Etching and aquatint*, 14 x 9 inches. (Illustrated)
110 In the Dull Village. *Etching*, 14 x 9 inches. (Illustrated)

A Selection from: Six Fairy Tales from the Brothers Grimm 1969, a portfolio of 39 etchings:
111 The Princess in Her Tower. *Etching and aquatint*, 17.75 x 13 inches. (Illustrated)
112 The Boy Hidden in a Fish. *Etching and aquatint*, 9.5 x 11 inches. (Illustrated)
113 Rapunzel Growing in the Garden. *Etching and aquatint*, 18 x 13 inches. (Illustrated)
114 Home. *Etching and aquatint*, 18 x 13 inches. (Illustrated)
115 A Black Cat Leaping. *Etching and aquatint*, 9.5 x 11 inches. (Illustrated)
116 The Sexton Disguised as a Ghost. *Etching and aquatint*, 9 x 10.5 inches. (Illustrated)
117 Old Rinkrank Threatens the Princess. *Etching and aquatint*, 9.5 x 11 inches. (Illustrated)
118 Cold Water About to Hit the Prince. *Etching and aquatint*, 15.75 x 11 inches. (Illustrated)

119 Flowers and Vase, 1969. *Etching and aquatint*, 27.5 x 21.5 inches. (Illustrated)
120 Celia, 1969. *Etching and aquatint*, 27 x 21.25 inches. (Illustrated)
121 Coloured Flowers made of Paper and Ink, 1971. *Lithograph*, 39 x 37.5 inches.
122 Mo Asleep, 1971. *Etching and aquatint*, 35 x 28.25 inches. (Illustrated)
123 Rue de Seine, 1972. *Etching and aquatint*, 26.75 x 21.25 inches. (Illustrated)
124 Panama Hat, 1972. *Etching and aquatint*, 16.5 x 13.5 inches. (Illustrated)

A Selection from: Weather Series, 1973, a portfolio of 6 lithographs:
125 Rain. *Lithograph*, 39 x 32 inches. (Illustrated)
126 Sun. *Lithograph*, 37 x 30.25 inches. (Illustrated)

127 Still Life with Book, 1973. *Lithograph*, 32 x 25.25 inches.
128 The Master Printer of Los Angeles, 1973. *Lithograph*, 48 x 32 inches. (Illustrated)
129 Celia Smoking, 1973. *Lithograph*, 38.5 x 28 inches.

130 Dark Mist, 1973. *Lithograph*, 35 x 28 inches. (Illustrated)
131 Celia, 8365 Melrose Avenue, 1973. *Lithograph*, 47.75 x 31.5 inches. (Illustrated)
132 Celia, 1973. *Lithograph*, 42.5 x 28 inches.
133 Henry, 1973. *Lithograph*, 15.75 x 11.75 inches. (Illustrated)
134 The Student: Homage to Picasso, 1973. *Etching and aquatint*, 30 x 22.5 inches.
135 Artist and Model, 1974. *Etching and aquatint*, 32 x 24 inches. (Illustrated)
136 Contrejour in the French Style, 1974. *Etching and aquatint*, 39 x 35.5 inches.
137 Two Vases in the Louvre, 1974. *Etching and aquatint*, 39 x 35.5 inches.
138 Gregory, 1974. *Etching*, 36.25 x 28.25 inches. (Illustrated)
139 Henry at Table, 1976. *Lithograph*, 29.25 x 41.75 inches. (Illustrated)
140 Henry, 1976. *Lithograph*, 14 x 12 inches. (Illustrated)
141 Joe McDonald, 1976. *Lithograph*, 41.25 x 29.5 inches.
142 Maurice, 1976. *Lithograph*, 36 x 27 inches.

A Selection from : The Blue Guitar, 1976–77, a portfolio of 20 etchings :
143 What is this Picasso? *Etching and aquatint*, 18 x 21 inches.
144 A Picture of Ourselves. *Etching and aquatint*, 18 x 21 inches.
145 A Tune. *Etching and aquatint*, 18 x 21 inches.
146 I Say They Are. *Etching and aquatint*, 18 x 21 inches.
147 Parade. *Etching and aquatint*, 21 x 18 inches.
148 Tick It, Tock It, Turn It True. *Etching and aquatint*, 21 x 18 inches.
149 The Buzzing of the Blue Guitar. *Etching*, 21 x 18 inches.
150 Serenade. *Etching and aquatint*, 21 x 18 inches.

We wish to thank all those owners who have permitted the reproduction of their works in this catalogue. Special mention should be made of the following collections from which works have been illustrated:

Maria Augstein, Hamburg
Galerie Claude Bernard, Paris
The British Museum, London
The Marquis of Dufferin and Ava, London
Maria and Henry Feiwel, New York
Mr. & Mrs. Thomas Gibson, London
Hirshhorn Museum and Sculpture Garden,
 Smithsonian Institution.Washington D.C.
Louis Kaplan, London
Kasmin Ltd, London
Gerhard Schack, Hamburg
Staatliche Graphische Sammlung, Munich
John Torson, New York
Waddington-Tooth Gallery, London
Whitworth Art Gallery, University of Manchester

We acknowledge with thanks the cooperation of the following photographers in supplying transparencies and prints of the works illustrated:

Galerie Claude Bernard, Paris
Cavendish Studios, London
Geoffrey Clements, New York
A.C. Cooper, London
Prudence Cuming, London
Mack, Manchester
Rodney Todd White and Son, London
Frank Thomas, Los Angeles
Trojan Photographic, Middlesbrough
Rodney Wright Watson, London

Photograph of the artist: Arthur Lambert, New York